100 PAINTINGS

From the Collections of the
National Trust

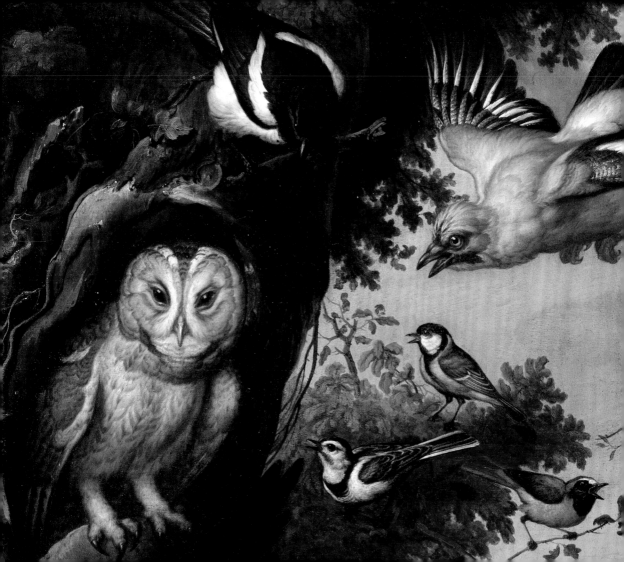

100 PAINTINGS

From the Collections of the National Trust

JOHN CHU AND DAVID TAYLOR

With an introduction by Tarnya Cooper and Sally-Anne Huxtable

 National Trust

Contents

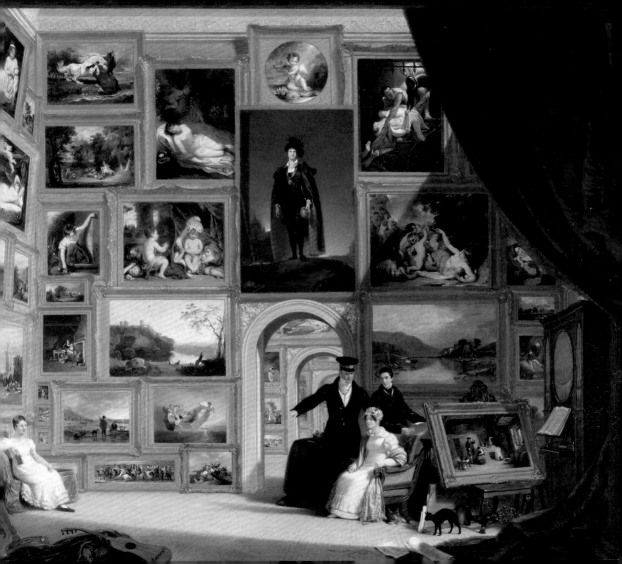

Introduction

This book of 100 paintings from the collections of National Trust properties celebrates why art matters to people. The pictures included here, from Italian Renaissance masterpieces to 20th-century British landscapes, all have stories of their creation and original meanings to tell. And yet, displayed in the context of National Trust houses or memorial spaces, they also remind us of the many reasons why art was created for domestic and public display – for example, as an aid to religious contemplation, to document and celebrate nature, to capture likeness, to remember loved ones and cement human relationships, to signal artistic passions, to enhance status, to mark and commemorate events, achievements or social movements, or simply for the pure joy of aesthetic pleasure.

Opposite · Sir Edward Herbert, later 1st Baron Herbert of Cherbury (c.1613–14) by Isaac Oliver (c.1565–1617), at Powis Castle, Powys (NT 1183954).

Frontispiece · Detail from An Owl Being Mobbed by Other Birds (1673) by Francis Barlow, at Ham House, Surrey (see pages 86–7).

Pages 4–5 · A Modern Picture Gallery (1824) by William Frederick Witherington, RA (1785–1865), at Wimpole, Cambridgeshire (NT 207839).

When visiting a historic house, we might expect to see impressive architectural spaces and richly decorated interiors, but we can also encounter astonishing works of art, particularly pictures. The paintings displayed in properties now owned by the National Trust across England, Wales and Northern Ireland amount to one of the finest collections of historic fine art in the world. Indeed, many National Trust houses should perhaps be considered miniature 'national galleries' for their counties, as they display paintings by some of the most renowned European artists, including Titian (c.1490–1576), El Greco (1541–1614), Hans Holbein the Younger (1497/8–1543), Sir Peter Paul Rubens (1577–1640), Sir Anthony van Dyck (1599–1641), Rembrandt van Rijn (1606–69), Pompeo Batoni (1708–87), Thomas Gainsborough (1727–88), Sir Joshua Reynolds (1723–92), William Hogarth (1697–1764), Elisabeth Louise Vigée Le Brun (1755–1842), George Stubbs (1724–1806), Angelica Kauffman (1741–1807), Sir Edward Burne-Jones (1833–98), James Tissot (1836–1902), Max Ernst (1891–1976), Vanessa Bell (1879–1961), Dame Barbara Hepworth (1903–75) and Sir Stanley Spencer (1891–1959), to name just a few.

Looking at a painting hung upon the walls of a country house is of course a very different

families, the pictures that filled their houses often signalled political, social or religious allegiance. In turn, depictions of family members or beloved pets frequently convey powerful and heartfelt personal attachments across time, or exemplify dynastic order and connections belonging to place. Other paintings, such as *Woman in a Red Dress* (c.1660–9), attributed to Gabriel Metsu, offer us a glimpse into the lives of people that would otherwise remain unrecorded by history.

Once the homes of aristocrats, the gentry and wealthy industrialists, or, for example, famous writers, artists or politicians, these properties are now open for the public to visit, discover and enjoy. Therefore, the National Trust's collections of pictures provide insights into the collecting patterns of the owners of National Trust houses and, inevitably, a sense of country-house taste over different periods. These patterns varied considerably over the course of the more than 500 years covered in this book, but often included portraits of family members, English landscapes and animal scenes of various sorts (horses, dogs, hunting scenes and other outdoor pursuits), emphasising the social class of the majority of the families connected with our properties, who inherited, commissioned and

experience from looking at the same picture in a museum or art gallery. The light conditions are lower and viewing positions can be at a distance, with paintings either high on a wall or behind grand furnishings. Instead, the experience provides us with a strong sense of how people have lived with and cherished art for centuries, and reveals the roles it played in their lives. Paintings, by their very nature, add layers of meaning to an interior. For wealthy and powerful

collected most of the National Trust's picture collections. Collections of paintings in houses functioned as statements of connoisseurship and taste, as well as, on occasion, expressions of newly gained wealth and success, such as Raffaello Sorbi's *An Italian Girl with Doves* (1866), one of the few surviving examples of the collection amassed at the 19th-century mansion Cragside by Lord Armstrong (1810–1900).

Some pictures were also commissioned or purchased for the places and actual spaces where they can be found today. One of the most remarkable examples of a display of pictures in somewhere near their original scheme can be found at the 17th-century mansion Ham House in the 'Green Closet'. Here, 16th- and 17th-century cabinet pictures and miniatures (including a depiction of Elizabeth I by Nicholas Hilliard (*c.*1547–1619), see overleaf) are hung closely together in a small room off the first floor corridor, allowing us momentarily to step into the shoes of a 17th-century viewer. Similarly, the displays of historic paintings collections in the North Gallery at Petworth, or throughout the houses at Kingston Lacy, Blickling Hall, Nostell, Powis Castle, Knole, Belton, Ickworth, Kedleston and Waddesdon (see gazetteer, pages 212–17)

Right · An Italian Girl with Doves (1866) by Raffaello Sorbi (1844–1931), at Cragside, Northumberland (NT 1230249).

all provide a powerfully vivid sense of the role paintings played in enhancing the status, power, charm and layers of meaning of domestic interiors at different periods.

The owners of country houses were often important patrons of artists, and particularly from the 18th century onward helped to establish a British school of painting. They often fostered the talents of artists, focusing on portraiture and landscapes, which in turn saw the development of

a vibrant art market. The outstanding collection at Petworth collected by George O'Brien Wyndham, 3rd Earl of Egremont (1751–1837), not only included Old Master and Dutch Golden Age works, but also reflected his patronage of innovative British artists such as J.M.W. Turner (1775–1851) (see pages 150–1) and William Blake (1757–1827) in the 18th and 19th centuries.

Other individuals and families who created important paintings collections include William John Bankes (1786–1855) at Kingston Lacy, Frederick Hervey, 4th Earl of Bristol and Bishop of Derry (1730–1803), who built Ickworth House to house his collection, the Sackvilles at Knole, Lord Bearsted at Upton, and the extended Rothschild family, who, alongside their gifts of Waddesdon and Ascott, bequeathed significant works that include a portrait of Lord Archibald Hamilton (see page 131) by Thomas Gainsborough (1727–88). Other collections are more personal: Virginia Woolf (1882–1941), for example, gathered a collection of works by her sister Vanessa Bell (1879–1961) at Monk's House (see page 187).

Some of the most impressive highlights and important groups of pictures at National Trust properties include the Golden Age Spanish picture collection at Kingston Lacy, the mid-17th-century collection of Sir Peter Lely (1618–80) portraits at Ham House (see pages 74–5), and the fine family portraits by Sir Thomas Lawrence (1769–1830) at Mount Stewart.

Perhaps surprisingly, the Trust also has many important 20th-century pictures, including excellent collections at Dudmaston (from the collection of Sir George Labouchère (1905–99) when he was British Ambassador to Spain) and the Derek Hill collection at Mottisfont. However, the standout 20th-century masterpiece is the Sandham Memorial Chapel cycle of paintings by Sir Stanley Spencer (1891–1959), considered among the most important and moving painted images of the First World War (see pages 194–7).

This book is intended to shine a light on these remarkable collections, provoke our curiosity and wonder at these and the many other pictures in our care and, of course, encourage future visits to destinations new and old. The quality, richness and depth of the National Trust's paintings collections has meant that bringing together the small selection presented in this book has involved difficult choices, and for every work here, another three or

four outstanding paintings could have been included. These rich collections can be explored in more detail on our collections website (www.nationaltrustcollections.org.uk), where you can also view online exhibitions and read expert articles that explore the visual language of landmark paintings such as the exquisite cabinet miniature of Edward, Lord Herbert of Cherbury (see page 6) by Isaac Oliver (c.1565–1617).

In making this selection, we have attempted to provide a chronological overview of paintings from different periods, to represent some of the major collections at Trust houses, and to indicate the depth of the collections, from portraits to genre scenes, conversation pieces to perspectives, and landscapes to architectural views. A glossary of technical terms appears on pages 210–11, and paintings that have been allocated to the National Trust through HM Government's hugely beneficial Acceptance in Lieu of inheritance tax scheme are indicated with the symbol ‡ at the end of the caption.

The research on our paintings collections, undertaken in earnest since the middle of the 20th century, owes much to past and present National Trust advisers, curators and conservators, and particularly to St John Gore (1921–2010) and Alastair Laing (the Trust's advisers on pictures and sculpture), to former paintings conservation adviser Christine Sitwell, and to curators David Taylor and John Chu, the authors of this book. Over the coming years we will continue to research the authorship of individual pictures and their provenance and contexts of production, undertake technical research and conservation to improve our knowledge and the condition of the paintings in our care, and continue to find opportunities to highlight the outstanding works of art in National Trust houses.

Tarnya Cooper, *Curation and Conservation Director, National Trust*
and Sally-Anne Huxtable, *Head Curator, National Trust*

Opposite · *Queen Elizabeth I* (c.1590) by Nicholas Hilliard (c.1547–1619), at Ham House, Surrey (NT 1140182).

Overleaf · Detail from *A Young Girl Holding a Chaffinch* (c.1615–22) by an unknown Flemish artist, at Upton House, Warwickshire (see page 49).

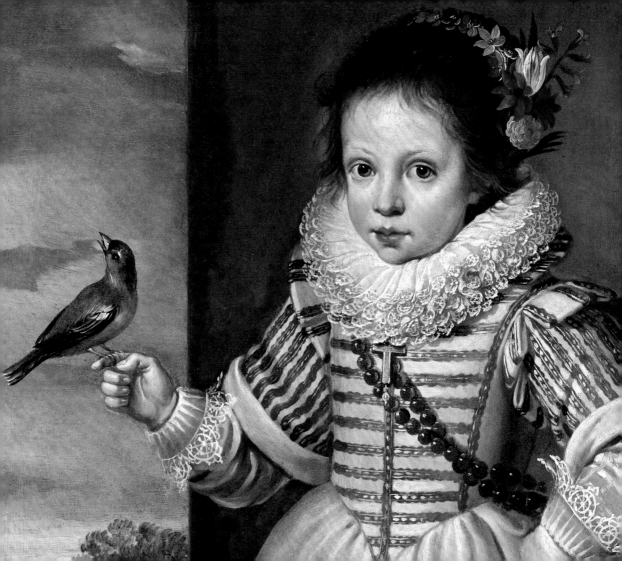

100 PAINTINGS

Humility and luxury

This small medieval Italian triptych was designed for private devotion. The side panels fold inwards, protecting the precious gilded and painted surfaces and making it portable. When opened out, scenes from the life of the Virgin Mary are revealed. In the central panel, the Virgin sits humbly on the ground, nursing the infant Christ. Humility, then believed to be the root of all virtue, is here offered as the focus of intimate reflection and prayer.

Despite its humble theme, the painter, Francescuccio Ghissi (active 1359–74), used highly expensive materials to accomplish this work. Gold leaf, indented with beautiful patterns to catch the light, covers much of the surface. The Virgin's robes, alive with a complex dragon pattern, are painted with precious blue pigment. These gleaming substances are introduced to evoke heavenly glory, but the result is an undeniably luxurious object. JC

Polesden Lacey, Surrey · Triptych with the 'Madonna of Humility' · *Francescuccio Ghissi · c.1359–74 · Tempera on panel · 45 x 20.9cm (central panel) and 45.7 x 11.4cm (wings) · NT 1246459*

Miraculous beginnings

This small picture depicts a momentous event in Rome on 5 August 352. Unseasonal snow falls from the sky, marking out a great cross on the ground. The Virgin Mary, who watches over the scene from heaven, had appeared in a dream to Pope Liberius, instructing him to build a church on a site that would be revealed by a miracle. He stands on the left, surrounded by clergy and dignitaries, raising a pick to break the ground and commence the work. A large church, Santa Maria Maggiore, has stood on the site ever since.

This is a rare, early work by the Italian Renaissance artist Pietro Perugino (c.1450–1523), who would go on to teach Raphael (1483–1520). There is a wonderful delicacy to the picture, especially in the painting of the hands and drapery. It once formed part of a *predella*. JC

Polesden Lacey, Surrey · The Miraculous Founding of Santa Maria Maggiore in Rome · *Pietro Perugino* · *c.1475* · *Oil on panel* · *18.4 x 40cm* · *NT 1246461*

A Netherlandish Epiphany

The early Netherlandish painter Hieronymus Bosch (c.1450–1516) is celebrated for his fantastical compositions filled with monstrous figures that once earned him the title 'the devil's painter'. However, his innovative religious paintings are also among his finest works. This triptych of the Adoration of the Magi, attributed to Bosch, includes a central panel based on his original version of this subject (Prado, Madrid). The flanking wings show the magi's guard looking at the (unseen) Star of Bethlehem, and St Joseph gathering sticks and water.

The central panel shows the three magi presenting their gifts to the Christ Child, held by the Virgin Mary, outside a ramshackle stable. The magi's clothes and gifts are decorated with scenes of suffering and salvation, revealing Christ's future life. The scene is witnessed by shepherds, two staring through a hole in the stable wall, while a nearly naked Antichrist watches at the doorway. DT

Upton House, Warwickshire · The Adoration of the Magi (Triptych) and Christ before Pilate (Verso) · *Attributed to Hieronymus Bosch · c.1495–1500 · Oil on panel · 91.4 x 72.4cm (central panel) and 88.3 x 28.9cm (wings) · NT 446744*

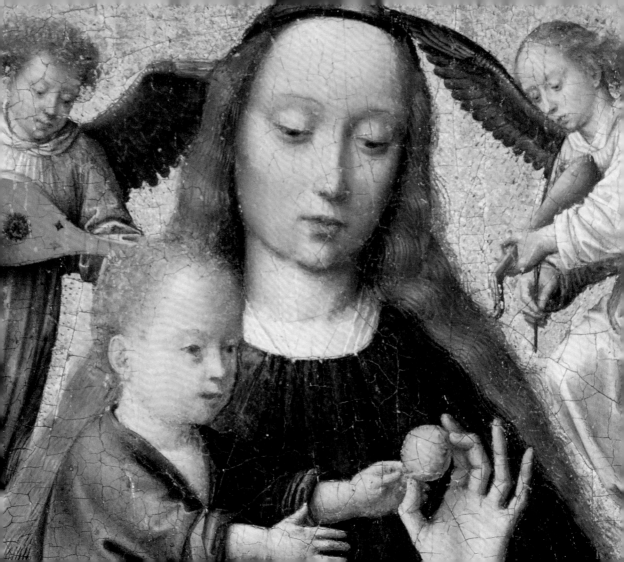

Heavenly music

The Virgin Mary hands the Christ Child an apple, while two angels float above playing musical instruments. This exquisite picture was painted by the famous Netherlandish artist Gerard David (*c.*1460–1523) around 1500. It would have been a thrilling acquisition when it was bought for Upton in 1938 by Walter Samuel, 2nd Viscount Bearsted (1882–1948), for his collection.

David, who was celebrated for his religious pictures, painted this image as one half of a diptych (the other half, *Christ Taking Leave of His Mother*, is in the Metropolitan Museum, New York), which would have opened like a book to be used for personal devotions. The apple that the Virgin passes to Christ is a reference to Eve handing Adam the same fruit in the Garden of Eden, and alludes to his future role as Redeemer. DT

Upton House, Warwickshire · The Madonna and Child with Two Music-making Angels · *Gerard David* · *c.1500* · *Oil on panel* · *15.6 x 11.7cm* · *NT 446754*

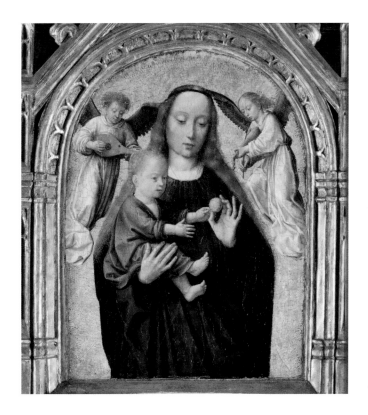

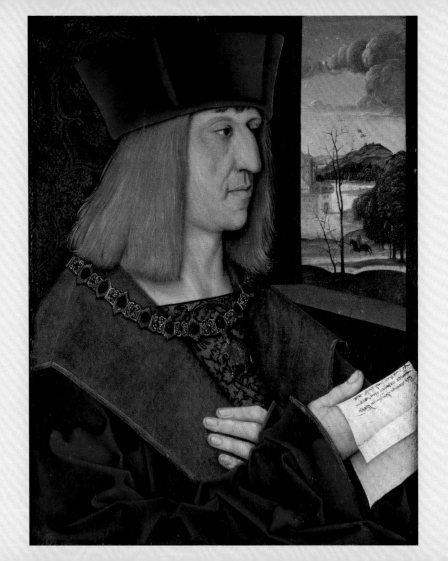

The last knight

Maximilian I (1459–1519) is depicted around the time he became Holy Roman Emperor by his court artist Bernhard Strigel (1460–1528). He wears the collar of the chivalric Order of the Golden Fleece around his neck and holds a petition, showing him as a fair ruler and worthy emperor. Maximilian encouraged such propaganda, which included his constructed persona as 'the last knight'. He was one of the most powerful members of the Habsburg dynasty, which ruled much of Europe and whose Spanish branch colonised large parts of the Americas and Asia. The Habsburg Empire lasted for 400 years after Maximilian's death.

Strigel was from southern Germany, and he and his workshop painted many portraits of the emperor, of which this informal but authoritative image is one of his finest. Strigel's realistic depiction shows Maximilian's protruding lower 'Habsburg lip' – a feature that, after years of inbreeding through close family marriages, could be seen in his descendants through the centuries. In 1943 the portrait was bought by Walter Samuel, 2nd Viscount Bearsted (1882–1948), who also owned a portrait of the emperor's son, Philip the Fair (1478–1506). DT

Upton House, Warwickshire · The Emperor Maximilian I · *Bernhard Strigel · c.1508 · Oil on panel · 39.4 x 30.2cm · NT 446803*

Inconceivable beauty

A powerful energy surges through this monumental painting by the Florentine Renaissance artist Andrea del Sarto (1486–1530). The infant Christ, accompanied by John the Baptist, twists forcefully on the lap of the Virgin Mary. His muscular form and the sculptural bulk of the Virgin express the gravitas of the painting's sacred subject. Particularly gripping are the alarmed, darting glances that the three figures cast out of the composition, as if alert to the dangers of a sinful world.

The picture is traditionally known as The 'Fries' Madonna, after its first known owner, Count Josef von Fries (1765–88). The author Goethe (1749–1832) saw it in the count's collection in Rome, not long after its acquisition. He declared it 'an incredibly beautiful picture', adding that 'one can't conceive of such beauty, without having seen it'. JC

Ascott, Buckinghamshire (Rothschild Ascott Collection) · Madonna and Child with the Infant Saint John (The 'Fries' Madonna) · *Andrea del Sarto* · *c.1520–1* · *Oil on panel* · *101.6 x 74.9cm* · *NT 1535140*

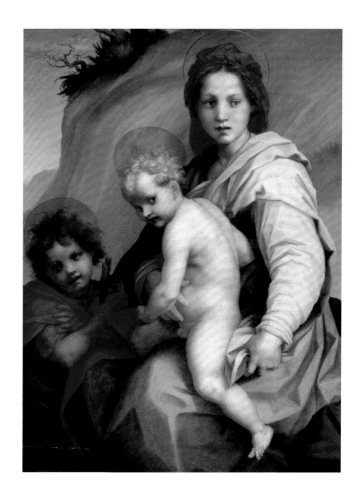

Portrait of an unknown Frenchman

The Dutch painter Corneille de Lyon (*c.*1500/10–75), originally from The Hague, was one of the great portraitists of the French Renaissance. Based in Lyons, he painted small-scale portraits of middle-class sitters, aristocrats and members of the royal court, eventually becoming the official painter of King Henri II (1519–59).

The sitter breaks into a tentative smile as he looks straight at us. He wears plain but expensive clothes, including a pink-lined, black doublet and a fashionable cap decorated with a gold cap badge and aiglets. We don't know who he is, but presumably the expensive act of commissioning a portrait from this particular artist was to commemorate something

important, such as his wedding, or a social or professional promotion. The work is typical of Corneille's portraits, which were all bust or half-lengths, with plain green or blue backgrounds. His naturalistic, refined images are more psychologically insightful than those of many of his contemporaries, and this picture would have been a highlight when Walter Samuel, 2nd Viscount Bearsted (1882–1948), bought it for his important picture collection at Upton. DT

Upton House, Warwickshire · An Unknown Man · *Corneille de Lyon* · *c.1535* · *Oil on panel (circular)* · *12.7cm diameter* · *NT 446780*

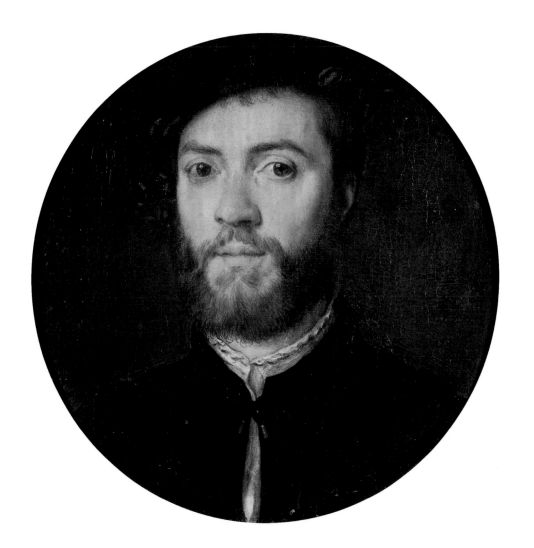

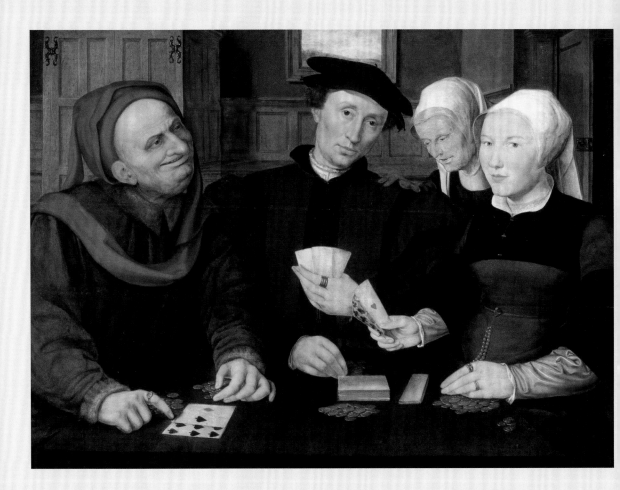

A game of morals

The Flemish painter Jan Massys (*c.*1509–75) often painted moralising tales in his images of couples mismatched in age, or scenes set in the offices of tax collectors or moneylenders. Likewise, depictions of card games in Renaissance pictures usually contain some sort of cautionary comment on good and bad behaviour. In this picture, the older man on the left stares lasciviously at the young woman. She ignores him and instead smiles out at the viewer, holding up the ace of hearts and protectively putting her hand on her pile of coins. The younger man in the middle stares out pensively, while an old lady places a reassuring hand on his shoulder. It is unclear whether he is being cheated or actively taking part in a scam. Massys based the old man on a similar figure in a painting of tax collectors by his famous father, Quentin Massys (1466–1530), whom he trained under in Antwerp.

The Card Players was the only 16th-century northern European picture acquired by Charles Wyndham, 2nd Earl of Egremont (1710–63). He paid the large sum of £48 for it in 1755 (the equivalent of around £5,000 today). DT

Petworth House, West Sussex · The Card Players · *Jan Massys* · *c.1535–45* · *Oil on panel* · *73.7 x 101.6cm* · *NT 486145* · *‡ 1956*

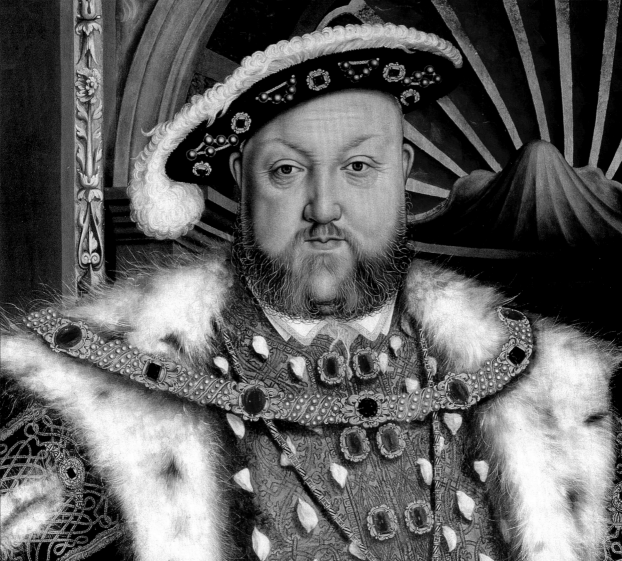

When you see me, you know me

This magnificent portrait from the studio of the German artist Hans Holbein the Younger (1497/8-1543) captures the essence of what we think of when we imagine Henry VIII (1491-1547). As only the second Tudor monarch, and facing various threats at home and abroad, it was vital for Henry to assert his political dominance. One way of doing this was through his image. This portrait is based on a mural painted by Holbein for Whitehall Palace to commemorate the Tudor dynasty. The king's posture is forceful and energetic, with his legs spread apart, his huge shoulder pads, and his hands flanking his prominent codpiece.

This version of the portrait was commissioned by Edward Seymour, 1st Duke of Somerset (*c.*1500-52), brother of the king's third wife, Jane Seymour (*c.*1508-37), who was depicted in Holbein's original mural at Whitehall. DT

Petworth House, West Sussex · Henry VIII · *Studio of Hans Holbein the Younger* · *c.*1543-7 · *Oil on panel* · *237.5 x 120.7cm* · *NT 486186* · ‡ *1956*

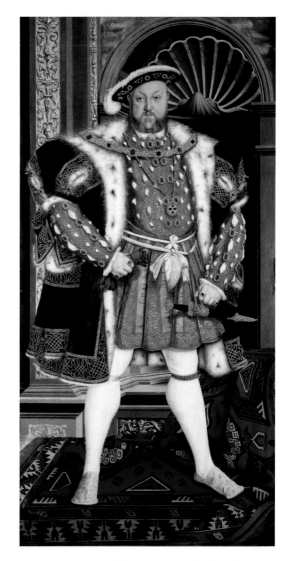

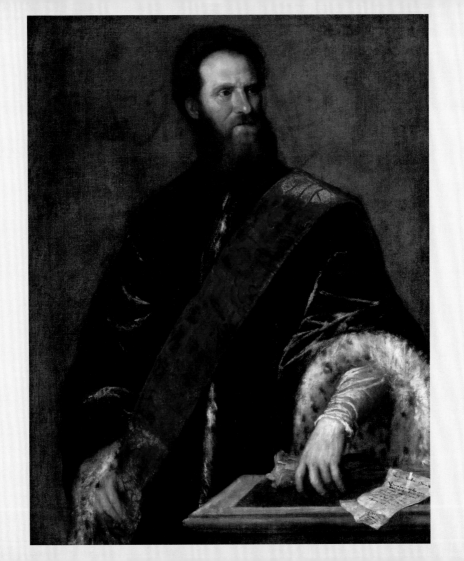

Knowledge is power

The great Venetian artist Titian (Tiziano Vecellio, c.1490–1576) was one of the most influential Renaissance painters, with an international reputation in his own lifetime. His innovative portraits influenced generations of artists. This example, depicting Nicolò Zen (1515–65), was mentioned by Titian's biographer Giorgio Vasari (1511–74), and was thought to be lost until the sitter's identity was rediscovered. Zen was a scientist, historian and politician, and the author of the disputed *On the discovery …* (1558), a text based on fabricated letters and maps that claimed his 14th-century ancestors discovered America. Titian painted Zen formally dressed in the ermine-lined velvet robes of a Venetian senator. His pose and placing on the canvas gives him a monumental, commanding presence. He holds his damask stole across his body and turns his head to look penetratingly into the distance, like a classical sculpture.

The picture was bought in Bologna in 1820 by the politician and explorer William John Bankes (1786–1855) as a portrait of an unknown senator in the Savorgnan family, and brought to Kingston Lacy to join his important collection of art and antiquities. DT

Kingston Lacy, Dorset · Nicolò Zen · *Titian (Tiziano Vecellio)* · 1560–5 · *Oil on canvas* · 125.7 x 96.8cm · *NT 1257086*

Fade to grey

A woman is shown sitting up in bed, brightly lit by a candle she holds, in an otherwise dark room. While not obvious at first, the scene we are observing is the death, or 'dormition' (falling asleep into death, without suffering) of the Virgin Mary. This is a monochromatic *grisaille*, painted in shades of grey to show off the skills of the artist. It is one of only three such paintings surviving by one of the greatest Netherlandish artists, Pieter Bruegel the Elder (*c*.1525–69).

Bruegel's landscapes and rowdy peasant scenes, sometimes based on children's games or Netherlandish proverbs, were often set in the contemporary world, as is the biblical story shown here. The Virgin Mary regards a crucifix, showing her son's death and reminding her of her forthcoming salvation, while Mary Magdalene rearranges her pillows and the silent crowd watches and prays. Across the room, near a messy table, St John sleeps, upright and open-mouthed, possibly dreaming the whole scene. Next to him a cat warms itself by a fire, oblivious to the important event unfolding behind it. DT

Upton House, Warwickshire · The Dormition of the Virgin · *Pieter Bruegel the Elder* · *c.1564* · *Oil on panel* · *67.7 x 85.3cm* · *Signed on chest at foot of bed: BRVEGEL* · *NT 446749*

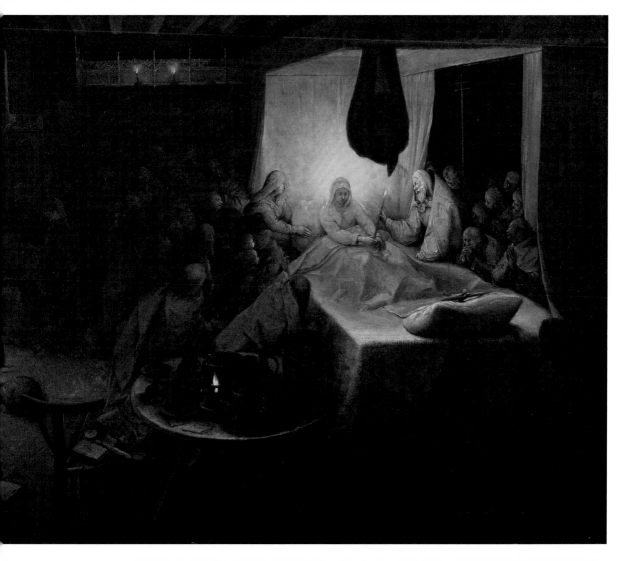

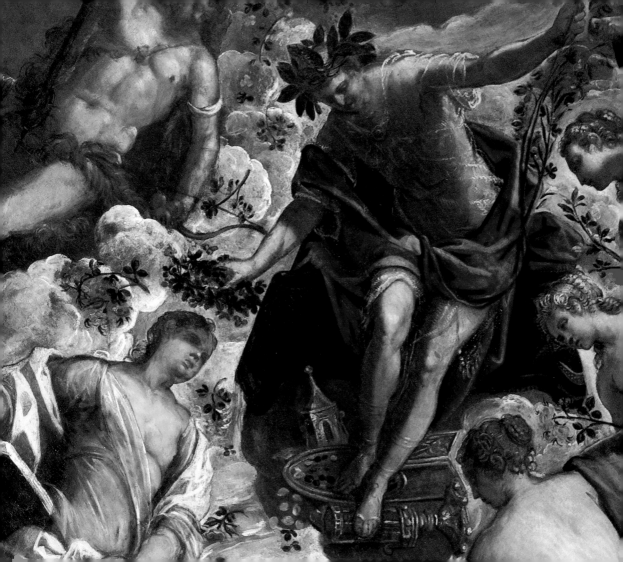

Heavens above

Jacopo Tintoretto (c.1518–94), a leading artist in 16th-century Venice, probably painted this work for the palace of a private patron. The figures, floating among clouds, are foreshortened as if seen from below, so the work must have been composed as a ceiling painting. Long encrusted with a layer of yellowed varnish, its rich hues were uncovered by cleaning in 2010.

Depictions of classical deities like this could hold specific meanings for their patrons that have been lost over time. This piece seems to celebrate a literary achievement. On the left, draped in blue, we see a poet holding a book and being crowned by the god Apollo. Looking on from above is Hercules, defender of the arts, with his club. On the other side, Fortune, identified by a large die, presents the poet with a horn of plenty. JC

Kingston Lacy, Dorset · Apollo Crowning a Poet ·
Jacopo Tintoretto · 1570s · Oil on canvas · 261.6 x 228.6cm ·
NT 1257229

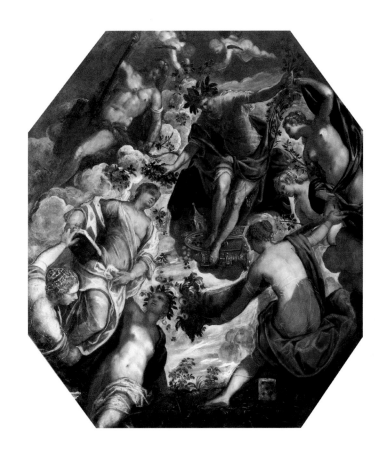

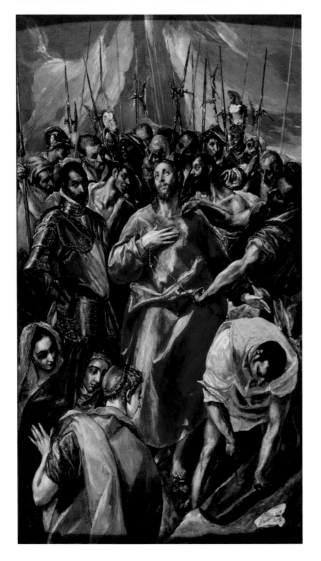

A Spanish masterpiece

Cretan-born and Venetian-trained Doménikos Theotokópoulos (1541–1614), known as El Greco, found fame in Spain, where he painted portraits and religious pictures. He produced several copies of his famous image of the disrobing of Christ, which he painted as an altarpiece for Toledo Cathedral, including this smaller version. The first owner of this picture was probably the cathedral's dean, Diego de Castilla (c.1510–84), who commissioned the original. El Greco's art exemplifies Mannerist painting with his elongated and contorted bodies, and his conceptual approach to composing his pictures. He is one of the most highly regarded painters of Spain's Golden Age.

Beneath an otherworldly sky, we see Christ about to be undressed before an angry mob. El Greco's intense colour and light add to the dramatic emotion of the scene. Christ gazes heavenward and serenely contemplates his impending crucifixion, apparently removed from the chaos and agitation around him. DT

Upton House, Warwickshire · El Expolio (The Disrobing of Christ) · *Doménikos Theotokópoulos (El Greco)* · *c.1577–9* · *Oil on panel* · *55.7 x 34.7cm* · *Signed in Greek on cartellino bottom right, mostly effaced* · *NT 446826*

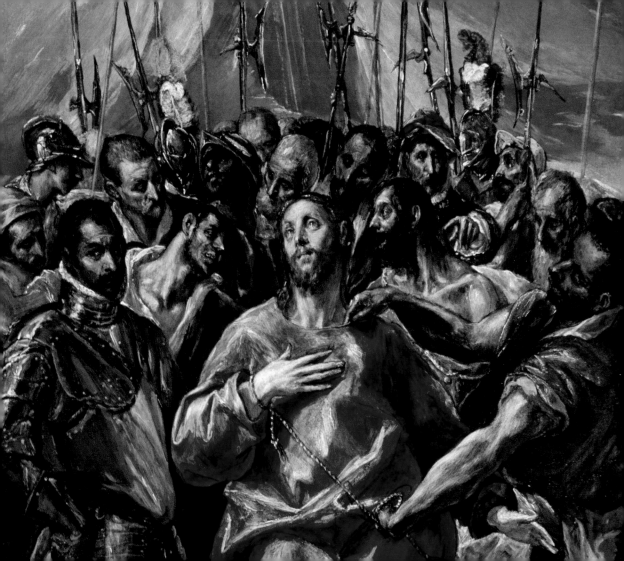

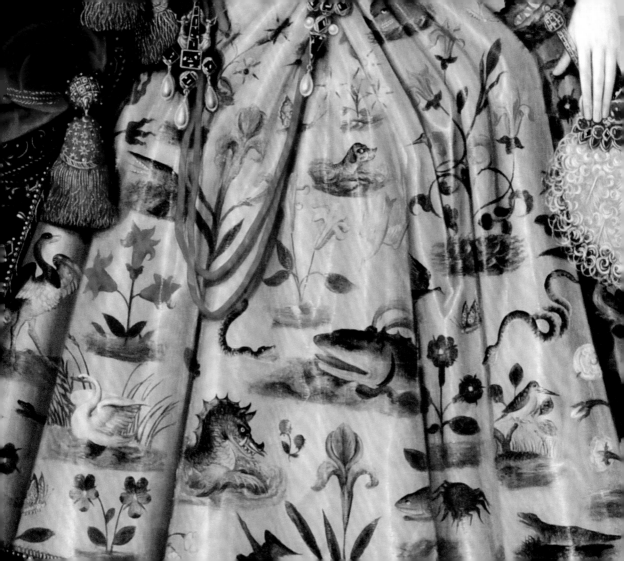

Picturing the virgin queen

This full-length portrait of Queen Elizabeth I
(1533–1603) was painted towards the end of
her life when she was in her sixties. After a reign
of 40 years, her likeness would have been well
known to her subjects. She was renowned for
her remarkable wardrobe and was described by
a contemporary around this time as 'gorgeously
apparelled'. Here she wears an elaborate silk or
satin dress decorated with sea monsters, flowers
and birds. Her status as unmarried virgin queen
is reflected in the hundreds of pearls (symbols
of purity) that decorate her clothes and crown.

The picture appears to have been purchased
for display at Hardwick Hall by Elizabeth Talbot,
Countess of Shrewsbury (?1527–1608), who
had served as a Gentlewoman of the Queen's
Privy Chamber. The style of the painting is
distinctively English, and the depiction of the
hair and face indicates that the likeness derives
from the earlier portraits of the well-known
miniaturist Nicholas Hilliard (c.1547–1619).
Although principally a miniaturist, Hilliard
was responsible for several large-scale oil
paintings. TC

Hardwick Hall, Derbyshire · Elizabeth I · *Attributed to
Nicholas Hilliard* · *c.1598–9* · *Oil on canvas* · *223.5 x 168.9cm
· NT 1129128 · ‡ 1958 (transferred to the National Trust, 1984)*

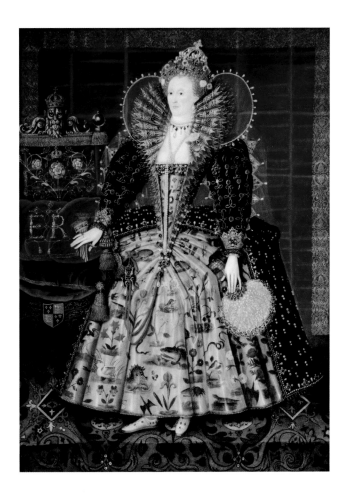

The road to salvation

Pieter Brueghel the Younger (1564–1638), from the great Brueghel family of painters (see pages 56–7), sets the scene of Christ's procession to Calvary in a familiar Flemish world. The finest of Brueghel's five versions of this picture, it shows the crowd making its way to the bleak hilltop execution site outside Jerusalem's city walls. Christ is almost lost in the throng of people, were it not for the cross he bears on his shoulder. Simon of Cyrene can be seen helping to take the weight of the cross, while St Veronica offers her veil for Christ to wipe the sweat from his face.

Many of the figures in the biblical story, such as the Virgin Mary weeping as the procession passes, or the good and bad thieves being taken to Calvary in a cart, are almost subsumed within the epic landscape and the hundreds of figures. Brueghel paid great attention to showing ordinary life in this complicated composition, from the contemporary clothes most of the people wear, to the typical Low Countries houses representing Jerusalem and the little windmill breaking the horizon in front of the Sea of Galilee. DT

Nostell, West Yorkshire · The Procession to Calvary · *Pieter Brueghel the Younger · 1602 · Oil on panel · 114.5 x 165.5cm · Signed and dated bottom left: P. BRVEGEL/1602 · NT 959460 · Acquired in 2011 with assistance from the Art Fund, the National Heritage Memorial Fund, other trusts and foundations, and donations from members of the public*

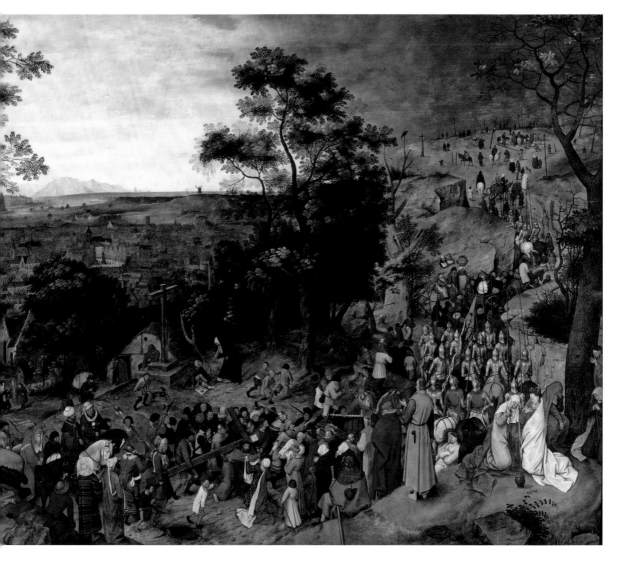

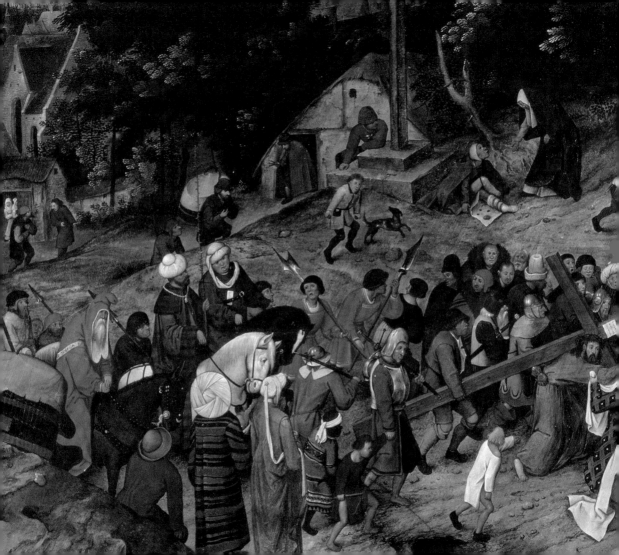

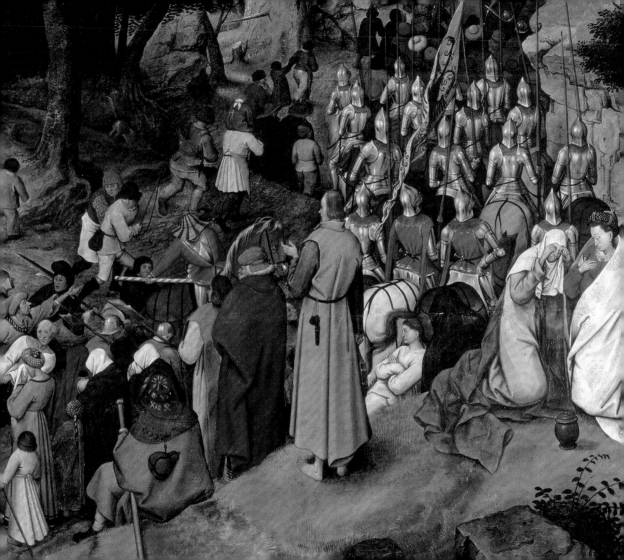

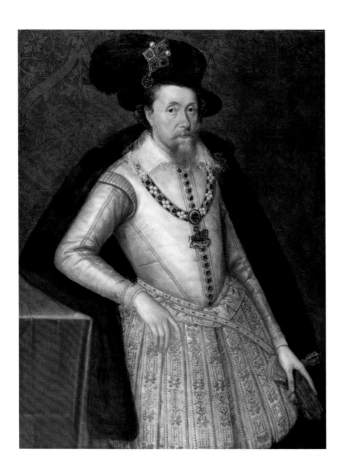

Mirror of Great Britain

Painted shortly after James VI of Scotland (1566–1625) inherited the English throne as James I, this image shows the Stuart monarch as ruler of both kingdoms. He wears the Great George of the Order of the Garter, the highest chivalric order in England, and the huge Mirror of Great Britain jewel, made to commemorate the union of the crowns, is pinned to his hat. James was one of our most intellectual rulers, writing philosophical books on demonology and theories of statecraft, and he sponsored the English-text Bible still known as the King James Version.

This portrait is one of many versions based on an original full-length design by John de Critz the Elder (c.1550–1642). The production of multiple versions of original portraits, such as this one, allowed images of the king to be disseminated among loyal courtiers or sent abroad as diplomatic gifts. DT

Montacute House, Somerset · James VI of Scotland and I of England and Ireland · *John de Critz the Elder* · *c.1606* · *Oil on panel* · *113 x 87.6cm* · *NT 2900021* · *Acquired in 2011 with assistance from the Miss Moira Carmichael bequest and other gifts and bequests*

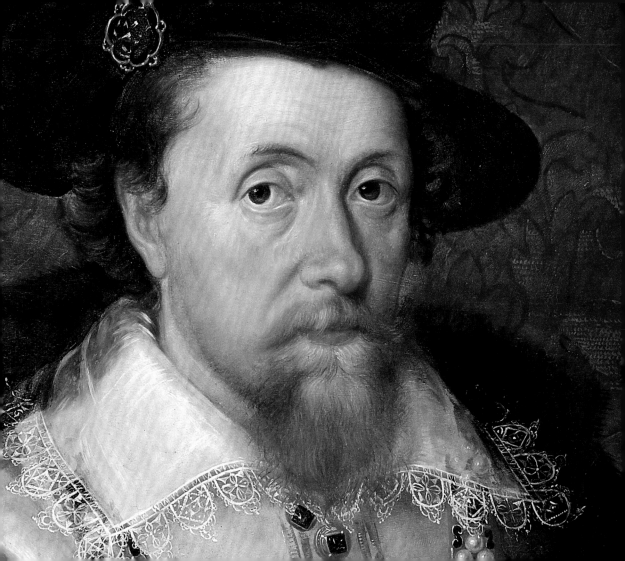

Re-inventing portraiture

The Flemish painter Sir Peter Paul Rubens (1577–1640) was one of the most celebrated and influential artists working in Europe in the 17th century. Ablaze with dazzling light, this portrait is one of his most accomplished early paintings and demonstrates his talent for staging portraiture as a form of drama. A young woman is depicted seated, dressed in a voluminous silver silk gown decorated with golden lace embroidery, her face framed by a splendid silver lace ruff. She has been identified as Maria Serra, the wife of banker Niccolò Pallavicino, and the picture appears to have been given as a gift, probably from the artist's employer, Duke Vincenzo I Gonzaga of Mantua.

Rubens spent part of his career in Italy, including at least two visits to the Republic of Genoa, where he undertook commissions from noble families. This picture was acquired in Genoa by William Bankes, the owner of Kingston Lacy, in 1840, along with another equally remarkable full-length female portrait by Rubens (NT 1257100). TC

Kingston Lacy, Dorset · *Marchesa Maria Serra Pallavicino · Sir Peter Paul Rubens · 1606 · Oil on canvas · 233.7 x 144.8cm · NT 1257098*

Poise, innocence and faith

This charming portrait of an unknown child was painted around 1620 by a talented but as yet unidentified Flemish artist. The child has been painted in the high spring or early summer and has flowers in her hair. She shows great poise and has been posed like a miniature adult with her hand upon her hip. It is likely she comes from a wealthy merchant or gentry family in Antwerp, and the gold cross at her neck indicates the family's Roman Catholic faith. She holds out a male chaffinch, which has a pinkish-brown chest and was renowned for its strong, cheerful song. Pet birds were common playthings in the 17th century and frequently appear in portraits of children.

The picture was formerly attributed to Cornelis de Vos (c.1584–1651) and is certainly by an accomplished artist working in Antwerp because it has a mark for the painters' Guild of St Luke in Antwerp on the back of the panel. TC

Upton House, Warwickshire · A Young Girl Holding a Chaffinch · *Unknown Flemish artist* · *Oil on panel* · *c.1615–22* · *94 x 63.5cm* · *NT 766119* · *Formerly at Cliveden, Buckinghamshire, currently on display at Upton House*

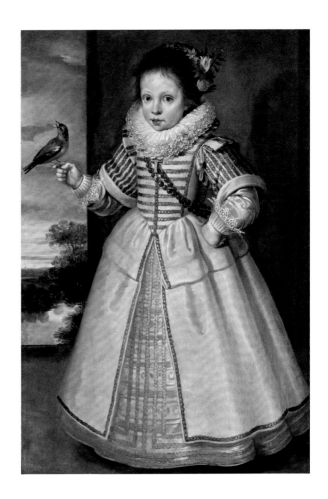

Power couple

Sir Anthony van Dyck (1599–1641) depicted one of the most exceptional partnerships of the 17th century in this pair of portraits. The seated woman is Teresa Sampsonia (c.1589–1668), a Circassian noblewoman of the Persian court of Shah Abbas I (1571–1629). She wed Sir Robert Shirley (1581–1628) in Isfahan, where he had been summoned to help improve the Persian army. Courageous and accomplished, they travelled together through Asia and Europe on extended diplomatic missions for the rest of their married life.

Van Dyck encountered the pair in Rome in 1622, where Sir Robert was received by the Pope as the Shah's ambassador. The painter, still in his early twenties, was in the city to work and

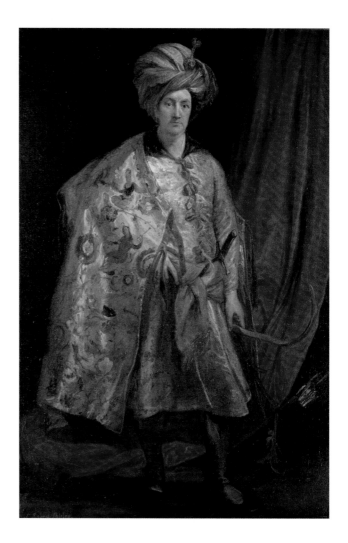

study. He was clearly struck by the couple's Persian clothes and deportment. Each is draped in sumptuous embroidered cloth of gold, prompting brushwork of astonishing fluency. Lady Shirley sits on cushions on the ground rather than on a chair, adhering to western Asian standards of decorum; her husband, in a stately turban, has clearly come a long way from his native Sussex. JC

Petworth, West Sussex · Sir Robert Shirley and Teresa Sampsonia, Lady Shirley · *Sir Anthony van Dyck* · *1622* · *Oil on canvas* · *Both paintings 214 x 129cm* · *Sitters' names inscribed lower left and lower right* · *NT 486169 and NT 486170* · ‡ *1956*

The parent trap

This complex, dramatically lit composition is a reimagining of an ancient myth in which Vulcan, god of volcanoes, used an iron net to catch his wife, Venus, in bed with Mars. This time, it is the bare-breasted goddess of love and the armoured god of war doing the ensnaring. Their prey is the goddess's son Cupid, boy-god of desire, depicted as a winged infant with chubby limbs flailing in the air. At the centre of the composition, the personification of Time, with his scythe and hourglass, wags his finger at the little troublemaker like a cross grandfather.

The Italian artist Guercino (1591–1666) was probably commissioned to paint this subject to convey a specific meaning. This has now been lost but it may be an allegory of the chastening of unruly desires through love, strength and experience. In the 18th century it was understood to be a representation of the stages of human life: childhood, youth, maturity and old age. Although undoubtedly a misreading, this interpretation justly reflects Guercino's ability to infuse even abstract personifications with rich humanity. JC

Dunham Massey, Cheshire · An Allegory with Venus, Mars, Cupid and Time · *Giovanni Francesco Barbieri, 'Guercino'* · *c.1624–6* · *Oil on canvas* · *127 x 175.3cm* · *NT 932333*

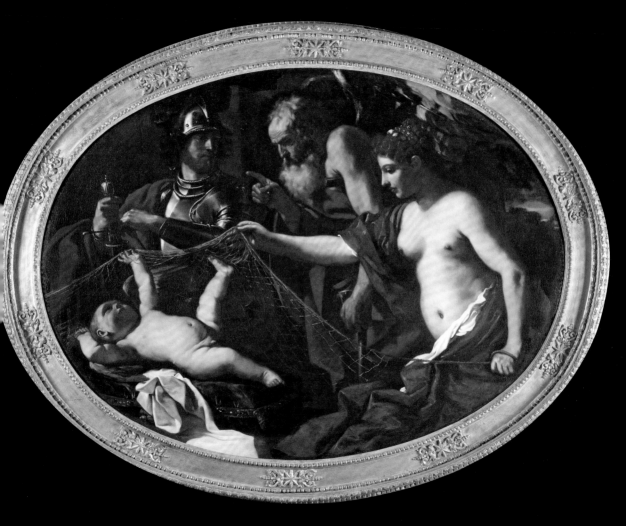

An enigma

Some pictures are easier to understand than others. In this case, even the subject has yet to be deciphered, although there are some clues. The palm fronds that each of these little boys holds are a symbol of Christian martyrdom. They are used in representations of saints who have died or undergone extreme suffering for their faith. Children are rarer than adults among the martyr-saints but they do exist. The third-century boy-saint Tarcisius, for example, was murdered by an angry Roman mob when he refused to give up the eucharistic bread and wine he was delivering to an imprisoned congregation during the Christian persecutions. Perhaps he can be identified with the watchful child in the centre of this picture, holding a container close to his body.

The painter of this work of art is also a mystery, despite its obvious quality. It has been suggested that it might be by Giovanni Antonio Galli (1585–1651/3), whose few securely attributed works are known for their elegiac atmosphere and delicate use of shadows. He was also skilled at painting children and liked to paint them in little groups. JC

Attingham Park, Shropshire · Three Boy Martyrs · *Attributed to Giovanni Antonio Galli* · *c.1600–49* · *Oil on canvas* · *66.7 x 49.5cm* · *NT 609074*

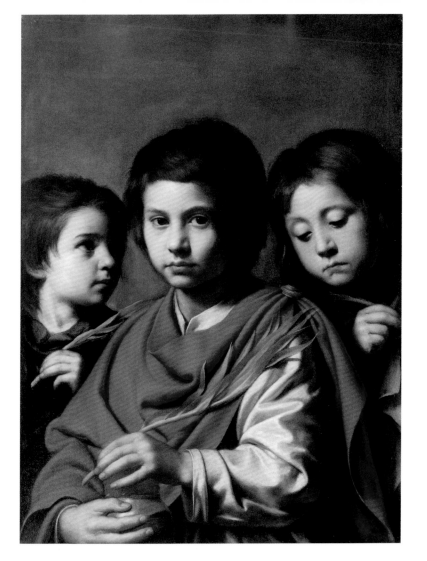

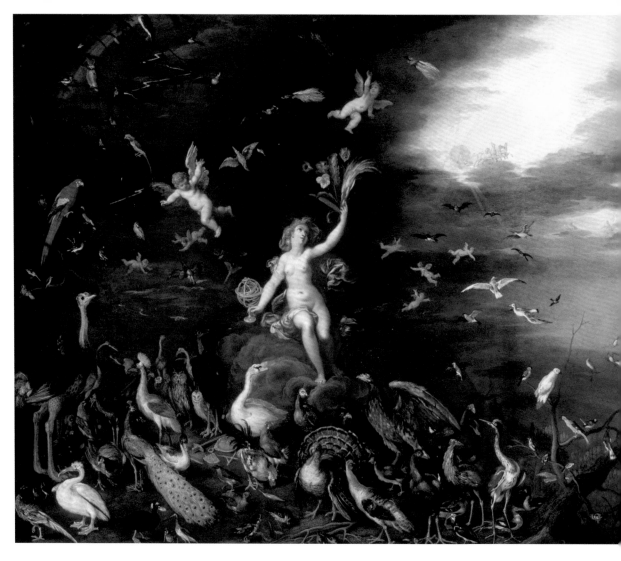

A natural understanding

Urania, the muse of astronomy, holds up a bunch of feathers as she sits on a cloud. A huge flock of exotic and domestic birds stands around her, while more fly in the sky, alongside bats and winged putti. The storminess above gives way to a brighter sky through which Apollo and Diana ride in their chariots.

This allegory of the element air was painted by Jan Brueghel the Younger (1601–78) in collaboration with Hendrick van Balen the Elder (1575–1632) as one of a set of the four elements. These were based on sets of the elements painted by Brueghel's father, Jan Brueghel the Elder (1568–1625), and his studio. The whole group was a late addition to the historic picture collection at Kingston Lacy, and was acquired after 1905. These innovative pictures cleverly combined emblems, classical figures and nature to convey their elemental subjects. DT

Kingston Lacy, Dorset · The Four Elements: Air · *Jan Brueghel the Younger and Hendrick van Balen the Elder* · *c.1625–32 · Oil on copper · 47.6 x 82.5cm · NT 1257084*

Love is blind

This strange, sensual painting is by the Italian artist Orazio Riminaldi (1586/93–1630). It depicts Cupid, the classical god of desire, lying asleep on the ground. His pale naked limbs – combining characteristics of infancy, adolescence and adulthood – stir as though he is waking up, or disturbed by a dream. Likewise, his exquisitely painted wings appear to quiver and flex in his slumbers. High in the air, Venus, the goddess of love, drives a chariot drawn by doves through the sky; a tiny figure dwarfed by the languid yet powerful presence of her son.

Cupid is blindfolded to indicate that this deity fires arrows of desire without rhyme or reason, bringing chaos and mischief in his wake. Ominously, at the bottom of the painting, his loaded bow points directly out into the space of the viewer. Is Riminaldi reminding us to be vigilant against the awakening of our own dangerous impulses? After all, the boy-god is evidently a light sleeper. JC

Kedleston Hall, Derbyshire · Cupid Asleep Approached by Venus in Her Chariot · *Orazio Riminaldi · 1628–30 · Oil on canvas · 84 x 114.5cm · NT 108831 · Acquired in 1987 with support from the National Heritage Memorial Fund*

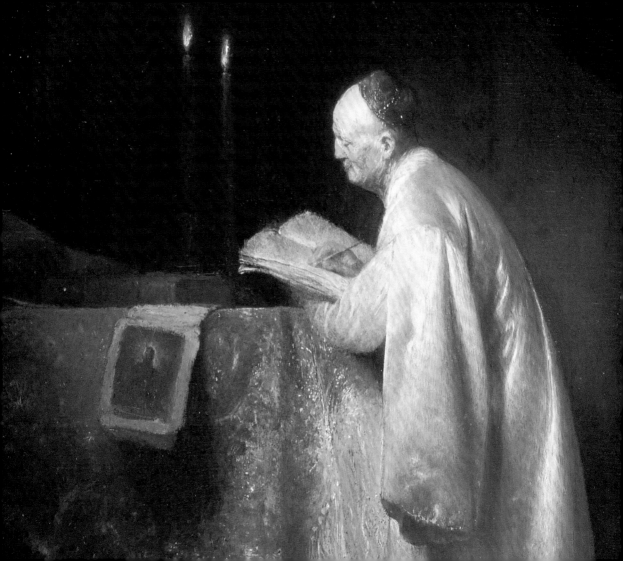

Out of the shadows

In this mysterious picture, lit by candles and a shaft of light from an unseen source, we see an old man standing at a table and writing in a book. We don't know who he is, but his scholarly skullcap and robes, and the fact that he holds a large book on an altar-like table, suggest he is a magus, a type of priest from ancient Persia.

Although painted by the celebrated Dutch artist Jan Lievens (1607–74), the picture intriguingly includes a false Rembrandt signature. The two artists were close friends, and for a while they shared a studio in the city of Leiden. Rembrandt must have liked the picture as he owned a copy of it, later described as a priest 'after Lievens' in a list of his possessions. At least ten versions were produced, but recent analysis has confirmed this is the original picture. DT

Upton House, Warwickshire · A Magus at a Table · *Jan Lievens · c.1631 · Oil on panel · 55.9 x 48.6cm · Inscribed and dated bottom left: Rembrandt f. 16[..]* · *NT 446728*

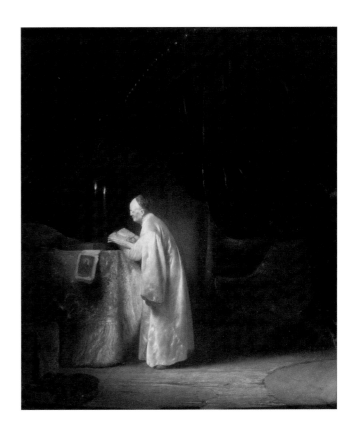

Cavalier attitudes

Robert Rich, 2nd Earl of Warwick (1587–1658), was a puritan aristocrat and an important administrator for England's colonisation of the Americas. He owned the frigate that in 1619 took the first enslaved Africans to a British North American colony. He fought for the Parliamentarians during the English Civil War.

Daniel Mytens the Elder (c.1590–1647/8), who painted this glamorous portrayal, was a fashionable court painter and we see the earl before he fell out with the Royalists. Mytens was superseded by the celebrated Flemish artist Sir Anthony van Dyck (1599–1641), who later painted Warwick in the same magnificent outfit (Metropolitan Museum, New York).

The portrait was moved from Chatsworth (one of Warwick's sons married into the Cavendish family) to Hardwick by the 6th Duke of Devonshire (1790–1858), who called it 'the red man' as the identity of the sitter had become confused. DT

Hardwick Hall, Derbyshire · Robert Rich, 2nd Earl of Warwick · *Daniel Mytens the Elder* · *1633* · *Oil on canvas* · *195.6 x 134cm* · *Inscribed and dated adjacent to sword hilt:* *ROBERT ERLE OF WARWICKE/ÆTAT. 45. Ao 1633* · *NT 1129114* · ‡ *1958*

All dressed up

We know what the popular Dutch artist Rembrandt (1606–69) looked like because he produced his own portrait many times. This portrait has had its attribution argued back and forth, but it was recently confirmed to be a self-portrait after technical analysis.

As well as being a recognisable image of Rembrandt, this picture is what is known as a *tronie* – a type of figurative painting that was hugely popular in the Netherlands in the 17th century. We don't know what type of person Rembrandt is dressed up as, but the costume is meant to look fanciful and timeless. His velvet cap was fashionable in the previous century, he wears an elaborately embroidered cape, he has a metal gorget from a suit of armour around his neck, and a Spanish coin, probably from a shipwreck, is suspended from a gold chain across his chest. DT

Buckland Abbey, Devon · Self-portrait, Wearing a Feathered Bonnet · *Rembrandt van Rijn · 1635 · Oil on panel · 91.2 x 71.9cm · Signed and dated lower right: Rembrant f: 1635 · NT 810136 · Given by the estate of the late Edna, Lady Samuel of Wych Cross, 2010*

The road less travelled

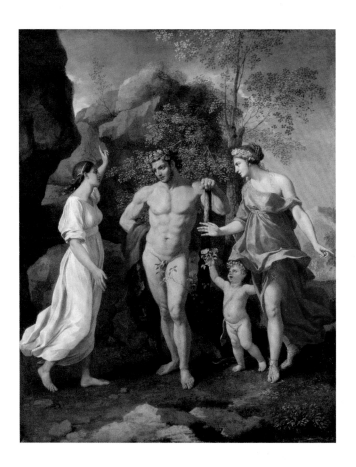

Hercules stands at the centre of this composition with a decision to make. On the right is the personification of Vice accompanied by Cupid; on the other side is Virtue. According to the ancient Greek writer Xenophon, these figures presented Hercules with a choice between a life of easy pleasures or difficult but glorious labours. When Nicolas Poussin (1594–1665) painted this picture, the story was popular as a reminder to the powerful to place the greater good above personal gratification.

Poussin brilliantly conveys the two arguments in visual form. Vice gestures with one hand towards a soft valley and extends the other caressingly towards the demi-god's naked torso. Virtue points the way up a steep, rocky path topped by sublime light. The symmetry of the composition implies that Hercules's choice hangs in the balance, although the twist of his body betrays that Virtue is winning out. JC

Stourhead, Wiltshire · Choice of Hercules · *Nicolas Poussin · c.1636–7 · Oil on canvas · 88.3 x 71.8cm · NT 732103*

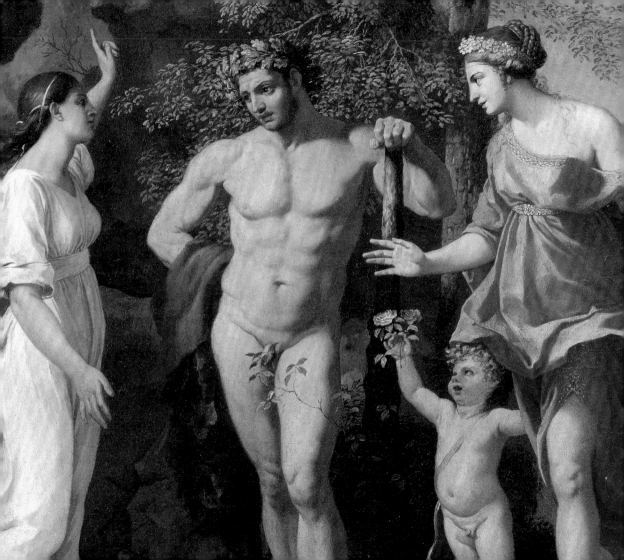

Lessons at the table

Pieter Claesz (1597–1660) was one of the most important of the Haarlem school of Dutch still-life painters, and a master of the fashionable *ontbijt* (breakfast piece). This picture exemplifies his skill in creating complex compositions and painting the effect of light over different, realistically depicted, material surfaces. We see a table, partly covered by a cloth, on which are a blue-and-white ceramic bowl of fruit, metal plates, bread rolls, a cooked crab, a coffee jug and decorative *rummer* drinking glasses. The perishable food, the knife balancing over the table edge, the butterfly on a vine leaf and the upturned and overturned glasses are all typical signs in the visual language of Dutch still lifes that the picture is a *vanitas* image, reminding us when we look at it that life is short and that we too will die.

Claesz dated the majority of his works, which helps us to understand the development of his painting style. We know this magnificent picture was painted during his last stylistic period, when his groupings of objects became busier and when he used more varied and brighter colours. DT

Nostell, West Yorkshire · Still Life of Food, a Jug and Glasses on a Table · *Pieter Claesz* · *1640* · *Oil on panel* · *62.9 x 87.6cm* · *Monogrammed and dated: A/PCH/1640* · *NT 960080* · *Acquired with support from the Heritage Lottery Fund, 2002*

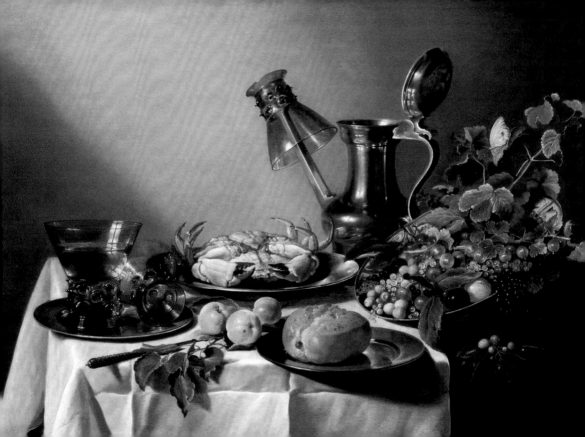

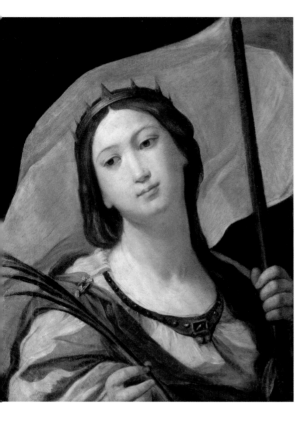

The graceful woman in this picture represents the 4th-century Christian martyr, Saint Ursula, who led 11,000 virgins on a pilgrimage to Rome from Britain (or Brittany in some versions of the legend). On the return journey they were massacred by an army of Huns. Her golden crown and the palm frond in her hand signify the place in heaven she earned through her goodness and suffering on earth.

The painting is by the Italian artist, Guido Reni (1575–1642). He became known as the 'Divine Guido' because his works were felt to glow with heavenly grace. Here, the beautiful symmetry of Ursula's features and her gentle expression point to inner spiritual perfection. The picture may be one of the unfinished canvases left in Reni's studio at his death. The saint's head appears to be the work of the master and the rest completed by assistants. JC

Saltram, Devon · Saint Ursula · *Guido Reni and studio* · *c.1642* · *Oil on canvas* · *57.2 x 45.7cm* · *NT 872077* · ‡ *1956*

Cardinal and collector

The apparent satisfaction of the sitter in this portrait, Cardinal Camillo Massimi (1620–77), who was a famous art collector, was probably because of his pleasure at being portrayed by the greatest of Spain's Golden Age artists, Diego Velázquez (1599–1660). The hugely influential artist painted religious pictures and tavern scenes, but it was his innovative skill as a portraitist that led him to become the trusted court painter of the King of Spain, Philip IV (1605–65).

The expensive ultramarine pigment used by Velázquez to paint the brilliant deep blue of the cardinal's soprana and cassock, along with the red and gold chair he sits on, add a grandeur to his depiction of the jowly churchman. One previous owner of the portrait was Gaspar de Haro, 7th Marquis of Carpio (1629–87), who also owned Velázquez's famous *Rokeby Venus* (National Gallery, London) in his celebrated art collection. DT

Kingston Lacy, Dorset · Cardinal Camillo Massimi · *Diego Velázquez · 1649–50 · Oil on canvas · 75.9 x 61cm · NT 1257142*

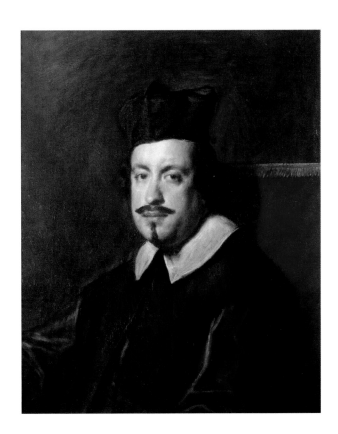

Pirates of the South China Sea

Billows of smoke rise about a chaos of Chinese junks and European tall ships. It is 9 February 1630 and an allied fleet of the Dutch East India Company and Chinese ships are attacking the pirate Li Kuiqi in the Bay of Xiamen (Amoy). This was part of a campaign by the Dutch to secure their sea routes and colonies in the region, having supplanted the Portuguese as the world's leading maritime trading power. By these actions, the Dutch sought to impress the Chinese imperial administration and increase their access to China's vast market but were to be disappointed in these ambitions.

This picture was painted in the Dutch Republic 20 years after the events it depicts by Simon de Vlieger (c.1601–53), a specialist in grand maritime paintings. He was known for his attention to detail and included the exact Dutch ships that fought in the battle: the *Texel*, the *Domburch* and the *Arnemude*. JC

Felbrigg Hall, Norfolk · Dutch East India Company and Chinese Attack on Pirates in the Bay of Xiamen (Amoy) · *Simon de Vlieger · 1650 · Oil on canvas · 188 x 264.2cm · Signed and dated: S de Vlieger 1650 · NT 1401166*

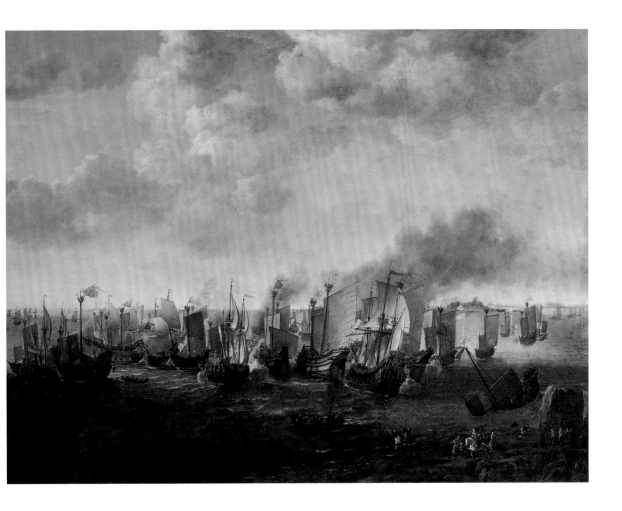

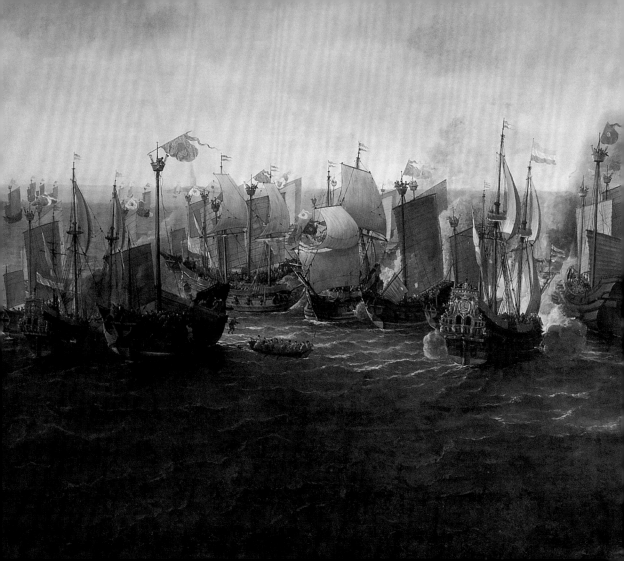

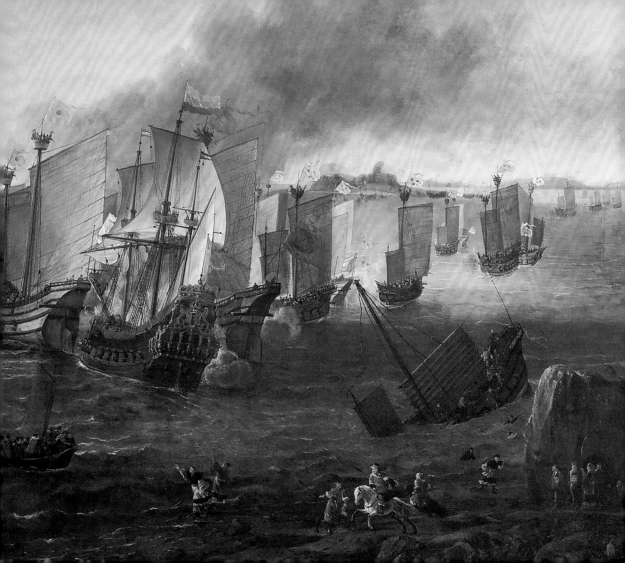

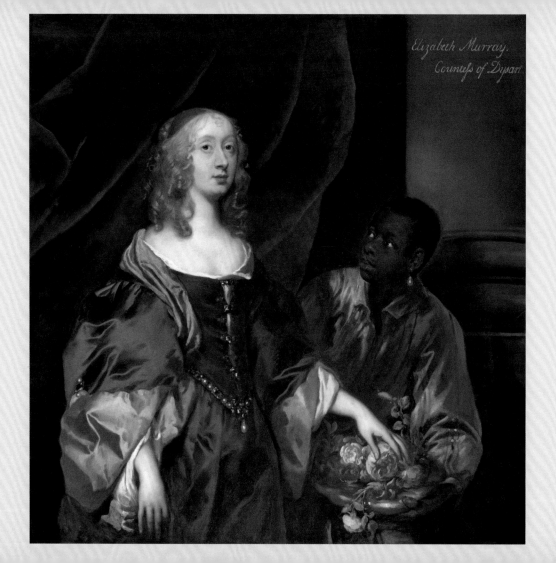

Elizabeth Murray.
Countess of Dysart

A tale of two sitters

The Scottish heiress Elizabeth Murray, Countess of Dysart (1626–98), inherited Ham House from her father. A prominent courtier and a hugely important patron, she filled her Thames-side house with highly fashionable furniture, textiles and paintings. The artist she was most closely associated with was the court painter Sir Peter Lely (1618–80), and he produced various portraits of her, her family and her political allies, over three decades.

This double portrait shows Elizabeth during her first marriage, to Sir Lionel Tollemache (1624–69). We do not know the identity of the second sitter in the portrait, but his deferential pose, offering her a bowl of roses, suggests he is her attendant. We know that people of African heritage worked at Ham, as paid or unpaid servants, so this may be a depiction of a real person. If so, there are no clues to his identity or to the restricted life he would have led. Real or made up, he plays a subordinate role in the portrait, his presence emphasising Elizabeth's wealth and power. DT

Ham House, Surrey · Elizabeth Murray, Lady Tollemache, later Countess of Dysart and Duchess of Lauderdale with an Attendant · *Sir Peter Lely · c.1651 · Oil on canvas · 124 x 119cm · NT 1139940 · Acquired by HM Government, 1948, and transferred to the Victoria and Albert Museum; transferred to the National Trust, 2002*

A little-known saint

St Christina of Bolsena was a little-known 3rd-century martyr who was repeatedly tortured and then put to death by her family for converting to Christianity. The Florentine artist Carlo Dolci (1616–87), famous for his meticulous and porcelain-like technique, painted it when there was a market for depictions of tortured female saints. This unusual image visually idealises the act of Christina's sanctity. It also fetishises the subject by showing a young woman in ecstasy, mouth open and eyes rolled back and raised towards heaven, with an arrow piercing her neck.

The picture was bought in 1758 from the art dealer William Kent (active c.1742–62) by Sir Nathaniel Curzon, 5th Baronet of Kedleston and later 1st Baron Scarsdale (1726–1804). It was one of the first purchases for the important picture collection that he formed, and it has been at Kedleston Hall, which he built, since the 1770s. Dolci's picture is remarkable because the panel it is painted on is integral to its carved gilt foliate frame. The 15th-century-style frame possibly indicates that the artist reused an older panel and frame when he painted the saint. DT

Kedleston Hall, Derbyshire · Saint Christina of Bolsena · *Carlo Dolci · c.1650–5 · Oil on panel (circular) · 28.6cm (diameter) · NT 108843 · Acquired with assistance from the Art Fund, 2002*

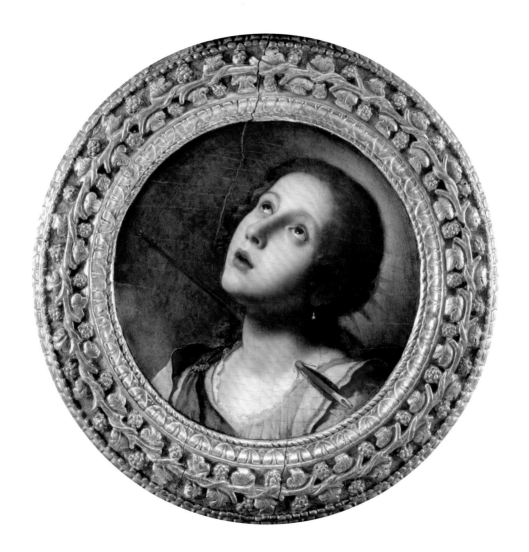

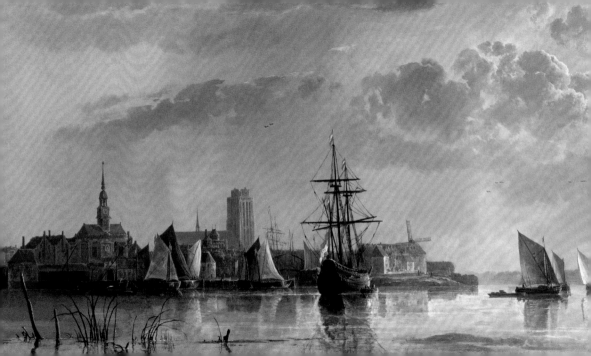

No place like home

The Dordrecht landscape artist Aelbert Cuyp (1620–91) painted many views of his hometown but this is undoubtedly the most spectacular. This Dutch port-city was a powerhouse of the timber trade, to which Cuyp alludes on the right-hand side of the picture with a log raft tethered to a freighter.

A sense of majesty is imparted to the scene by the effects of the setting sun. Its warm light rakes across the whole picture, picking out buildings, clouds and even the tips of reeds in the river. By such atmospheric light effects, Cuyp built a considerable reputation in Dordrecht in his lifetime. His fame went international in the mid-18th century, when British art-lovers began importing his works in large numbers. Demand at that time was such that this painting was cut in two, although it was thankfully later restored to its panoramic form. JC

Ascott, Buckinghamshire (Rothschild Ascott Collection) · View of Dordrecht from the North · *Aelbert Cuyp* · *c.1655* · *Oil on canvas* · *83.5 x 207cm* · *NT 1535110*

Street art

From the streets of the 17th-century port of Seville, a curly-haired boy looks us in the eye and laughs. He is pointing at an old woman eating a bowl of *migas* (breadcrumbs) with a spoon. She leans away from him and looks over her shoulder, as if dismayed by his impertinence or defending her meagre meal. Beside her a dog stares longingly at the *migas*.

This scene of street life was painted by the Spanish artist Bartolomé Esteban Murillo (1617–82), who was best known for his religious paintings. Depictions of the urban poor like this were an important sideline and were popular with northern European collectors. This brilliant showcase of Murillo's ability to capture the detail of ordinary people's lives was probably first brought to Dyrham House by its owner and builder, William Blathwayt (?1649–1717), who had family connections to Mediterranean trade. JC

Dyrham Park, Gloucestershire · An Urchin Mocking an Old Woman Eating Migas · *Bartolomé Esteban Murillo* · *c.1660–5* · *Oil on canvas* · *147.3 x 106.7cm* · *NT 453754* · *Purchased by the Ministry of Works, 1956, and transferred to the National Trust, 1961*

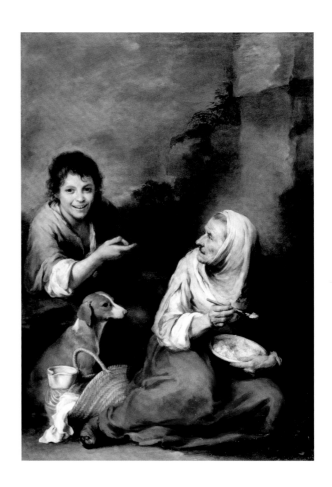

Music and meaning

This small painting by Gabriel Metsu (1629–67) is a particularly fine example of a cabinet picture. Metsu was an important Dutch Golden Age artist who was a master at portraying different materials in light and shadow, exemplified here in the woman's satin skirt and fur-lined, velvet jacket, and in the Turkey rug folded back over the table.

The title of the picture, *The Duet*, describes the courtship as well as the musical relationship between the man and woman. However, the picture is full of details that hint at other, less obvious meanings. The man stares at the woman while he tunes his lute, the instrument of love, which to a 17th-century Dutch audience was an obvious sexual metaphor. A dog seems to bark a warning at the woman, who is lost in her thoughts as she prepares to sing. DT

Upton House, Warwickshire · The Duet · *Gabriel Metsu · c.1660 · Oil on panel · 39.4 x 29.2cm · Signed at the bottom of the sheet of music: G. Metsu · NT 446725*

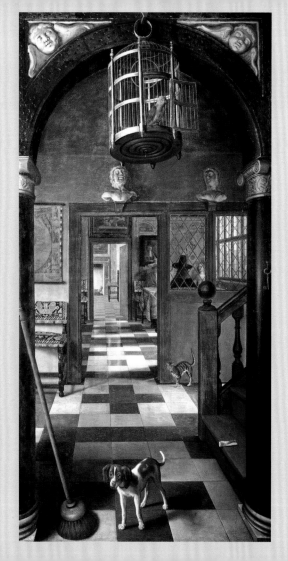

Deceiving the eye

This *trompe l'oeil* picture by Samuel van Hoogstraten (1627–78) has delighted viewers ever since it was commissioned by the artist's friend Thomas Povey (1613/14–c.1705) in London in 1662. Another person in their circle was the diarist Samuel Pepys (1633–1703), who wrote of it, 'above all things I do most admire his piece of perspective especially'.

Hoogstraten was a master of the 'threshold picture', a type of painting that looked through open doorways into imagined interiors. In this enigmatic example we are met by an inquisitive spaniel and a parrot at the door of its cage, drawing us into the succession of rooms. We are taken past a letter dropped on a staircase and a wary cat, towards a group of people conversing at a table. At Dyrham the picture is first seen through a suite of rooms, emphasising its clever trick of perspective. DT

Dyrham Park, Gloucestershire · A View through a House · *Samuel van Hoogstraten · 1662 · Oil on canvas · 264.2 x 136.5cm · Signed and dated: S. V. Hoogstrat.../1662; and dated on map: 1662 · NT 453733 · Purchased by the Ministry of Works, 1956, and transferred to the National Trust, 1961*

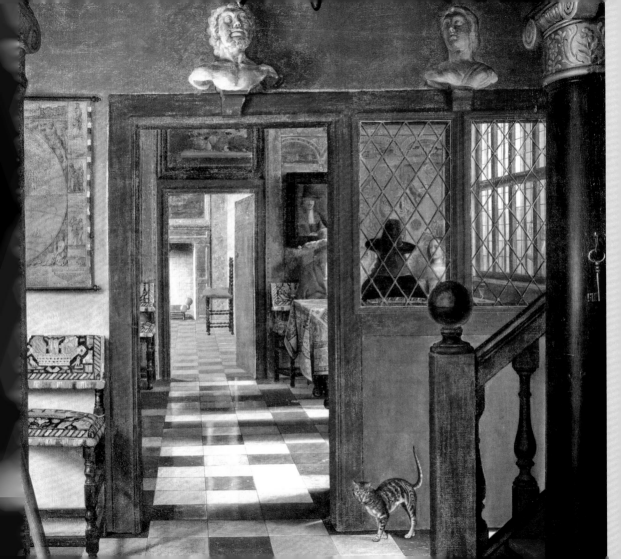

Ray of light

Jacob van Ruisdael (1628–82) blended reality and imagination in this landscape. Sunlight has burst through a cloudy sky, momentarily bathing a stretch of the Netherlandish countryside in golden light. Ruisdael was expert at creating magnificent cloudscapes that bring drama to the flat terrain of the Dutch Republic. Here, a parting in the clouds draws the eye down to the city of Alkmaar on the far horizon. Closer to is the ruined castle of Egmond, which in reality sits on low ground but in this painting is raised up on invented hills, a dark mass just touching the steely tones of the sky.

This prospect would have had deep historical resonance for its first admirers. The siege of Alkmaar of 1573 was a major event in the Dutch Republic's long struggle for freedom from Spanish rule. Large areas of surrounding farmland were flooded to repel the Spanish. Egmond Castle was deliberately destroyed to stop it falling under their control. As well as capturing a fleeting moment in the landscape, Ruisdael evoked the sacrifice and perseverance of the nation. JC

Upton House, Warwickshire · Le Coup de soleil (Fantasy View of Alkmaar) · *Jacob van Ruisdael* · *1669–75* · *Oil on canvas* · *40 x 40.6cm* · *Signed: JvR* · *NT 446731*

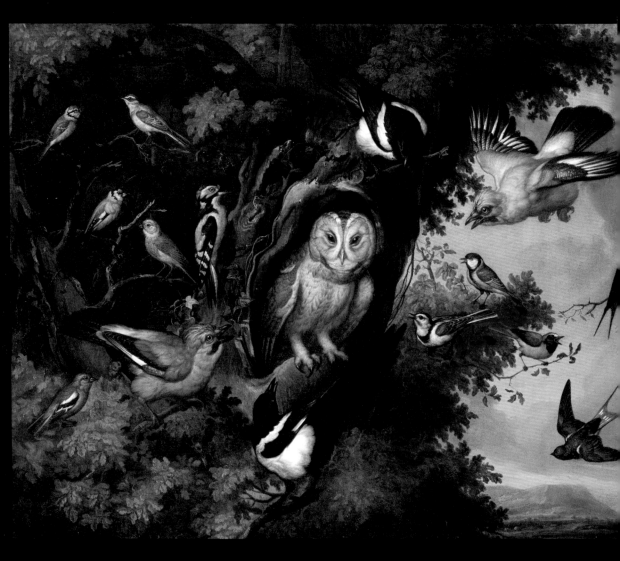

An unruly mob

The prolific painter and etcher Francis Barlow (c.1626–1704) was considered the father of English sporting painting and book illustration. He was described by the diarist John Evelyn (1620–1706) as 'the famous Paynter of fowle, Beasts & Birds'. As such, his pictures of various species of birds were fashionable objects to own during the particularly rich period of artistic production in later 17th-century England.

In this picture, a tawny owl is shown sitting in the hollow of an oak tree at the edge of a forest, being mobbed by pairs of magpies and jays and other smaller songbirds. Mobbing is the noisy harassment of a predator by a number of birds, and in this picture it might be a metaphor for some other subject, now unknown to us. To the right of the picture is a group of swallows by a fragment of classical architecture, and in the background the sun sets over distant hills. The picture was one of two that Barlow painted in 1673, for the Duchess of Lauderdale (1626–98, see page 75) that were inserted over the doors in 'my Lady's Chamber' at Ham House. DT

Ham House, Surrey · An Owl Being Mobbed by Other Birds · *Francis Barlow* · *1673* · *Oil on canvas* · *88.6 x 134cm* · *NT 1140159* · *Acquired by HM Government, 1948, and transferred to the Victoria and Albert Museum; transferred to the National Trust, 2002*

Coming in to land

Claude Lorrain (1600–82) is celebrated as one of the key figures in the history of landscape painting. The sense of perfect balance in his compositions, which became the benchmark for the art form for centuries to come, is here found in its full development. The subject is the landing of the Trojan hero Aeneas at Pallanteum, where he would go on to build the city of Rome. It was commissioned in 1675 by Gasparo Paluzzi degli Albertoni (1646–1720), who had married into the Roman Altieri family. They traced their lineage back to Aeneas and it is the Altieri coat of arms that appears on his ship.

Claude's works were admired more highly in 18th-century Britain than perhaps at any other time or place. They were imported from Italy in large numbers, fuelling innovation in parkland design and the emergence of the British landscape painting tradition. This example was shipped into the country in 1799 at great expense by William Beckford (1760–1844), who had inherited one of the largest estates in the Caribbean and a huge labour force of enslaved Africans. JC

Anglesey Abbey, Cambridgeshire · The Arrival of Aeneas at Pallanteum · *Claude Lorrain* · *1675* · *Oil on canvas* · *190.5 x 238.5cm* · *Inscribed, signed and dated: Larrivo d'Anea a palant [eo] al monte evantino Claudio. Gille. inv. fecit. ROMAE. 1675* · *NT 515654*

Power dresser

The imposing figure in this portrait is Prince Rupert of the Rhine (1619–82). He was the son of the Elector of the Rhine and King of Bohemia but made his name as a soldier fighting for his cousin, Charles I (1600–49), in the English Civil War. Here we find him as an elder statesman of the court of Charles II (1630–85) at the end of a varied career as an admiral, privateer, colonialist and scientist.

He sports an enormous frizzy wig that was a feature of the extravagant fashions of the Restoration court. His robes, tassels and badges are those of the chivalric Order of the Garter, indicating his closeness to the Stuart monarchy. These are painted in remarkable detail by the artist, Simon Verelst (1644–1721), who was known for such illusionistic effects. JC

Petworth, West Sussex · Prince Rupert of the Rhine · *Simon Pietersz Verelst* · *c.1680–2* · *Oil on canvas* · *126 x 102cm* · *Inscribed: Prince Rupert* · *Signed: S. Verelst F.* · *NT 486254* · *‡ 1956*

Still life with swan and peacock

Jan Weenix (1642–1719) was one of the great Dutch still-life painters, often depicting dead birds and game in garden landscapes. His close attention to capturing realistic likenesses of different species, as well as his mastery of light and shadow, meant his pictures were highly desirable to collectors. Here we see dead birds, as bounty, positioned in front of a sculpted urn and a basket of expensive fruit, with a formal garden in the background. A dead swan and peacock, hung from a branch by their foot and neck respectively, dominate the picture. The swan's simple white plumage contrasts sharply with the magnificent tail feathers of the peacock, and a message about the pointlessness of vanity might be intended.

The picture is displayed within a gilt decorative overmantel of floral wreaths, probably made by the firm George Jackson & Sons, and bought by Adelbert Brownlow Cust, 3rd Earl Brownlow (1844–1921), to decorate the dining room at Belton. It is surmounted by a gilt swan in flight, referring to this picture, which Brownlow inherited, and other bird pictures in the room by the artist's cousin, Melchior d'Hondecoeter (1636–95), which the earl bought in 1873. DT

Belton House, Lincolnshire · A Dead Swan and Peacock · *Jan Weenix* · *1708* · *Oil on canvas* · *170 x 150cm* · *Signed and dated bottom left: J Weenix 1708* · *NT 436162* · *Acquired with assistance from the National Heritage Memorial Fund, 1984*

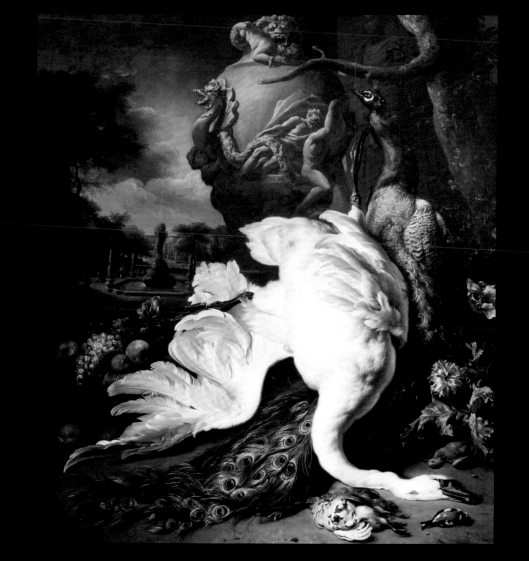

All is vanity

This exquisite picture was painted in the early 18th century by Rachel Ruysch (1664–1750), one of the most highly regarded Dutch still-life painters. The attention to detail in capturing the naturalism of the fruit and flowers haphazardly arranged at the bottom of a stone plinth and tree trunk are typical of Ruysch's work. In this *vanitas* still life details such as the lizard stealing eggs from a bird's nest and the rotting fruit act as symbolic reminders that life is short and all earthly pursuits are vanity.

Ruysch was the first female member of the Confrerie Pictura, an academic artists' society in The Hague. When she painted this picture she was employed in Düsseldorf as a court painter to Johann Wilhelm, Elector Palatine (1658–1716), an important patron who bought works by many other contemporary female artists. DT

Dudmaston, Shropshire · Still Life with Fruit, Bird's Nest and Insects · *Rachel Ruysch* · 1716 · *Oil on canvas* · *76.2 x 57.1cm* · *Signed top left on plinth: Rachel Ruysch 1716* · *NT 814164*

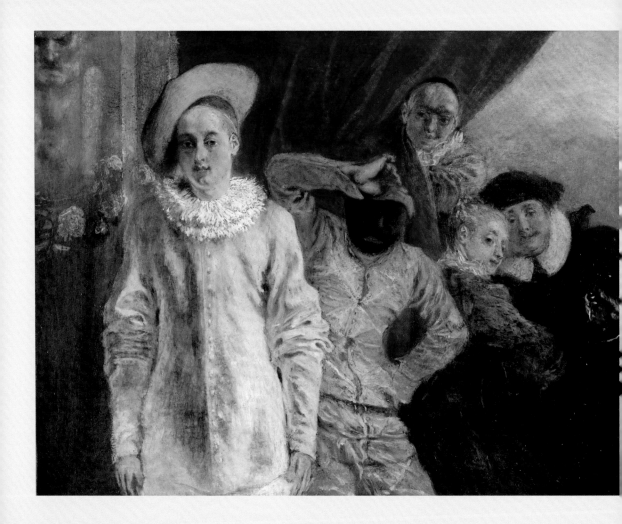

Noises off

Antoine Watteau (1684-1721) fused melancholy and frivolity in his highly original theatrical paintings. Here, a group of characters from the *commedia dell'arte* appear to gather on either side of a theatrical curtain – strangely half inside and half outside the realm of performance. As each gazes or glances back at the viewer, some aspect of their character is revealed in their demeanour. Most prominent is the mournful clown Pierrot, whose arms dangle innocently at his side. Just behind him lurks the nimble figure of Harlequin, face hidden disquietingly behind a mask.

Watteau's sophisticated pictures were a sensation in early 18th-century Paris and were influential throughout Europe for the rest of the century. His pictures were popular at an early stage in England, which Watteau visited towards the end of his short life. This work was in the famous collection of the portraitist Sir Joshua Reynolds (1723-92). JC

Waddesdon Manor, Buckinghamshire · Pierrot, Harlequin and Scapin · *Antoine Watteau* · *c.1719* · *Oil on panel* · *19 x 23.5cm* · *Waddesdon 2374* · *Bequeathed by James de Rothschild, 1957*

An Englishwoman in Paris

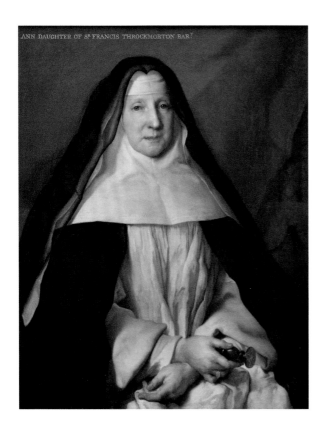

The woman gazing serenely out of this picture is Anne Frances Throckmorton (1664–1734). She was the prioress of Notre-Dame-de-Sion, a convent of Augustinian nuns in Paris known as the *Filles Anglaises* (English Daughters). For centuries after the Reformation, English Catholics such as Anne had to go abroad to follow their religious vocation.

This masterful portrait was commissioned by the sitter's nephew, Sir Robert Throckmorton (1702–91), from one of Paris's top painters, Nicolas de Largillière (1656–1746). The picture's quality points to its importance to Sir Robert. Back in England, he hung it in his home along with two further likenesses by Largillière of his sister and cousin, who had also taken holy vows. Together, these portraits expressed the defiant Catholicism of the Throckmortons, but also the family's pride in the faith and individual achievements of these women. JC

Coughton Court, Warwickshire · Prioress Anne Frances Throckmorton · *Nicolas de Largillière* · *c.1729* · *Oil on canvas* · *80 x 63.5cm* · *Inscribed: ANN DAUGHTER OF SR FRANCIS THROCKMORTON BART* · *NT 135583* · *Acquired with assistance from the National Heritage Memorial Fund and the Art Fund, 1991*

Back to school

A smartly dressed boy stands before his governess in this intimate painting by the French artist Jean-Siméon Chardin (1699–1779). The books under the boy's arm show that he is getting ready to go to school. The governess, pausing while brushing his hat, leans forward a little, perhaps to deliver a gentle reprimand before he departs.

Chardin had first found success as a still-life painter, as is evident in the sensitive depiction of the basket and scattered playthings. Domestic scenes like this, offering perceptive meditations on children and servants at work or play, were a more recent development. Inspired by 17th-century Dutch art, he developed a distinctive artistic vision of everyday life – at once restrained yet full of life.

The special qualities of these household scenes have long been appreciated by British art-lovers, who were among their earliest collectors. JC

Tatton Park, Cheshire · La Gouvernante (The Governess) · *Jean-Siméon Chardin · c.1738 · Oil on canvas · 45.7 x 38.1cm · Indistinctly signed: chardin · NT 1298184*

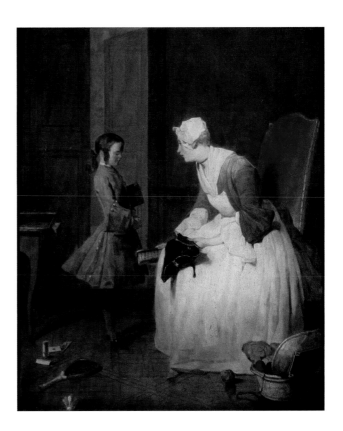

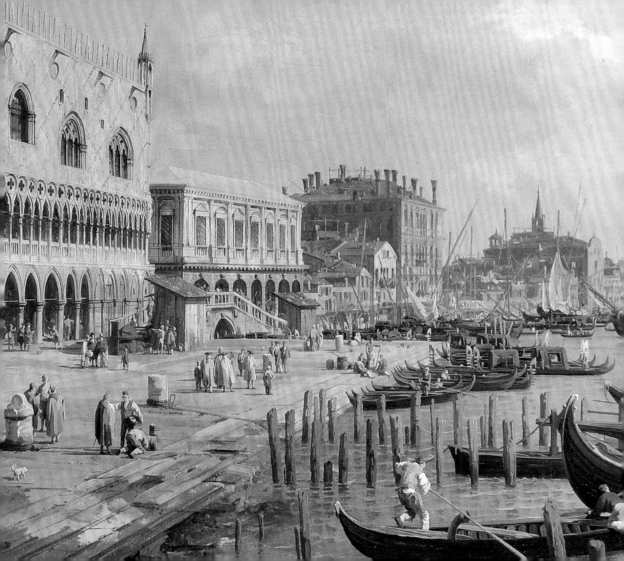

Life in Venice

The beautiful buildings of Venice are bathed in sunshine in this pair of paintings (see pages 104–5) by Antonio Canaletto (1697–1768). They capture two views taken from the same spot: one facing east towards the Doge's Palace, the other facing west towards the domed church of Santa Maria della Salute. With swift, lively brushstrokes, Canaletto captured the coming and going of pedestrians and gondolas along the wide stone quay known as the Molo. Here is ordinary life in an extraordinary city.

Famed for its art, architecture, parties and casinos, Venice was a major destination for 18th-century British visitors to Italy. Views like these were acquired as vivid reminders of the high times to be had there. Canaletto, who dominated this field, was in great demand and it proved difficult to get him to finish painting this particular pair of pictures. Their commissioner, Samuel Hill (?1691–1758), was told by his agent in Venice that the artist was so conscious of his popularity 'that he would be thought in this to have much obliged *me*'. JC

Tatton Park, Cheshire · The Doge's Palace and Riva degli Schiavoni, Venice; and The Grand Canal, Piazzetta and Dogana, Venice · *Antonio Canaletto* · *1730* · *Oil on canvas* · *59.7 x 101.6cm and 59.7 x 102.9cm* · *NT 1298196 and NT 1298203*

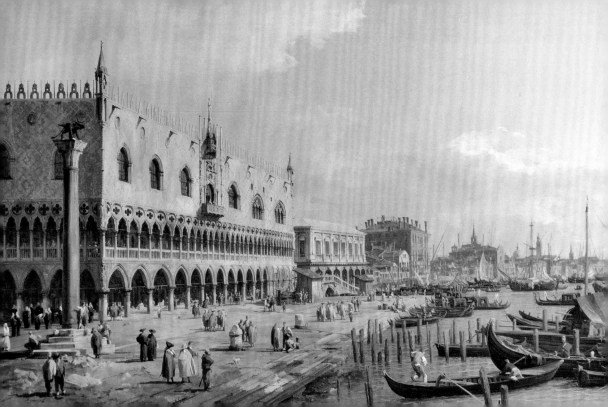

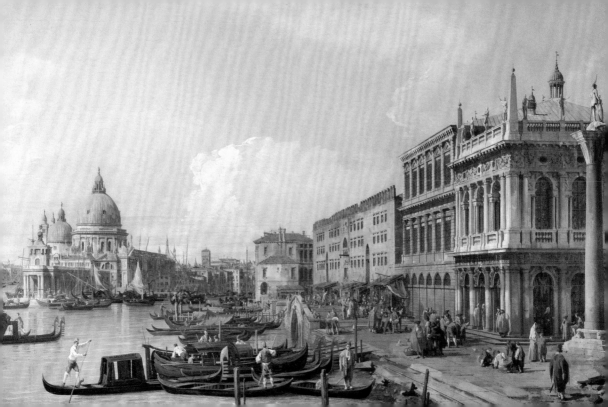

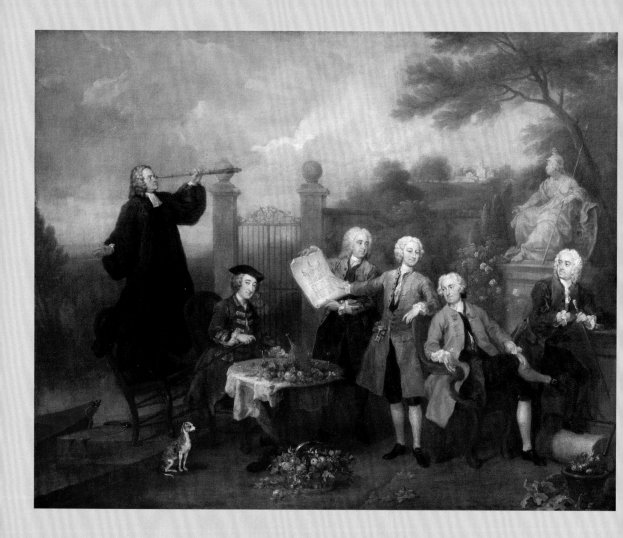

A private joke

This conversation piece shows a group of close friends linked by their social class, attachment to court and political sympathies, as they enjoy each other's company outdoors. William Hogarth (1697–1764) painted the picture between 1738 and 1740 for John Hervey, 2nd Baron Hervey of Ickworth (1696–1743), who stands at the centre of the group. He points at an architectural plan of a banqueting house, held by Henry Fox, later 1st Baron Holland (1705–74), whose older brother Stephen Fox, later 1st Earl of Ilchester (1704–76), sits at the table. The latter's walking stick has upset the chair that the Reverend John Theophilus Desaguliers (1683–1744) stands on, as he peers at a distant church through a telescope, and he is presumably about to fall into the river behind him.

Hogarth adds symbolic elements to emphasise the group's friendship, some of which remain enigmatic, while others are clearer – a dog for loyalty, a statue of Minerva for their intellectual pursuits, and roses for love, both platonic and physical. Hervey had love affairs with at least one other sitter in the portrait and was romantically infatuated with another. DT

Ickworth, Suffolk · The Hervey Conversation Piece · *William Hogarth · 1738-40 · Oil on canvas · 101.6 x 127cm · Signed bottom right on flowerpot: W. Hogarth pinxt · NT 851983 · ‡ 1956 (transferred to the National Trust, 1990)*

The builder saint

Saint Thomas was Christ's disciple who famously doubted his master's resurrection until he saw and touched the crucifixion wounds. Leaning on a classical pedestal, he holds in his left hand his personal attribute, a builder's set square. This refers to an apocryphal New Testament story of him being asked to build a palace in India, where he preached and where he was martyred.

This picture is one of a set of 12 paintings of God the Father and the Apostles by the acclaimed Roman artist Pompeo Batoni (1708–87), commissioned in 1740 by the artist's great patron Count Cesare Merenda (1700–54) for his palace in the Italian city of Forli. After the collection was sold in 1959, the pictures were dispersed to various museums and collectors, but eight of the set were bought by Lord and Lady Iliffe and are now at Basildon. Batoni was the favourite artist of 18th-century British Grand Tourists, whom he painted in Roman settings among classical ruins, and his portraits have remained popular in Britain ever since. However, religious pictures of this kind are highly unusual in English collections. DT

Basildon Park, Berkshire · Saint Thomas · *Pompeo Batoni* · *c.1740–3* · *Oil on canvas* · *73 x 60.5cm* · *NT 266904*

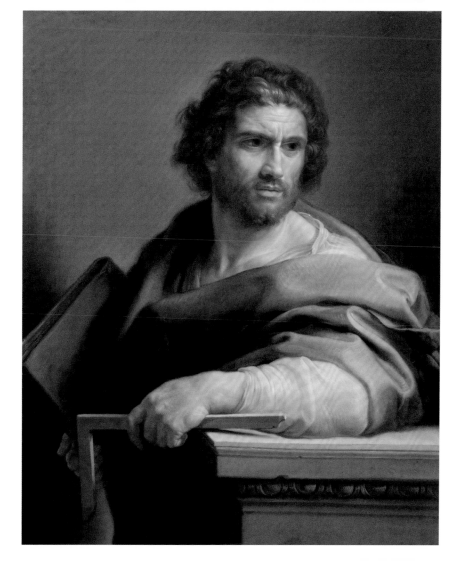

The view from above

When George Booth, 2nd Earl of Warrington (1675–1758), completed alterations to his Cheshire house, Dunham Massey, including its gardens and grounds, he employed the painter John Harris II (1715–55) to record the results. The four pictures that Harris produced are bird's-eye views, a popular topographical landscape form where the viewer could look down upon the subject depicted and see a wider sweep of land than in a traditional landscape. This, along with the obvious technical skill needed to imagine what the view looked like from above, was meant to impress. Harris's views of Dunham follow a precedent from the previous century, when Warrington, soon after he inherited Dunham, commissioned the Dutch artist Adriaen van Diest (1655–1704) to paint a bird's-eye view in c.1697.

Such views were going out of fashion when Harris painted his set, and these are among the last English examples of the formal landscape depicted in this way. Of all Harris's pictures of Dunham, this one stands out for its experimental distorted perspective, making this innovative view look surprisingly modern. DT

Dunham Massey, Cheshire · A Bird's-eye View of Dunham Massey from the South-east · *John Harris II · 1750 · Oil on canvas · 99 x 139.9cm · NT 932336*

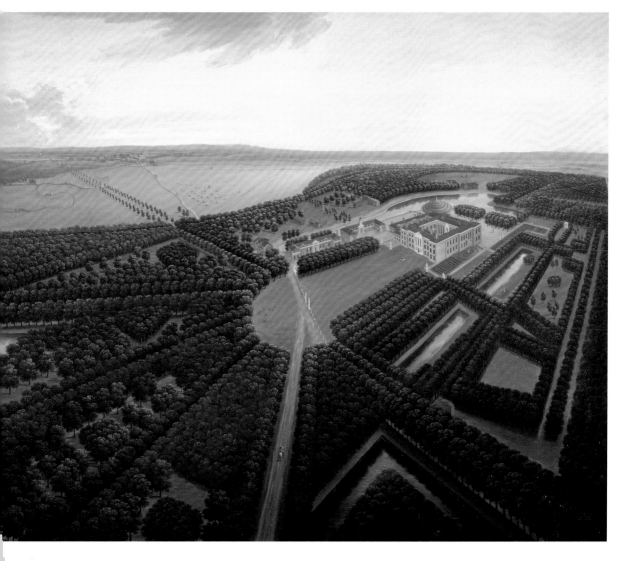

Drawn to nature

Sarah, Lady Fetherstonhaugh (1722–88) arranged flora and fauna across this composition with exquisite skill. Using the miniaturist's medium of watercolour on parchment, she deployed tiny brushstrokes to define the outline and textures of her subjects, including a red-handed tamarin, a dead goldfinch and a sprig of fruiting cherry. It is one of a number of similar paintings by her that still decorate Uppark in West Sussex. She was mistress of the house in the middle of the 18th century and may well have painted it there.

Lady Fetherstonhaugh's creations were evidently driven by scientific as well as artistic interests, and drew on recently published zoological prints. The impish primate in this piece is adapted from an etching by George Edwards (1694–1773) depicting a specimen that had been brought to Britain by ship from the Caribbean in 1747. She preserved the original scale of the print, which in turn faithfully reproduced the size of the real animal. JC

Uppark House, West Sussex · West Indian Little Black Monkey with Birds, Butterflies and Flowers · *Sarah Lethieullier, Lady Fetherstonhaugh* · *1757* · *Watercolour on parchment* · *Dated: 1757* · *42 x 51cm* · *NT 138308.1*

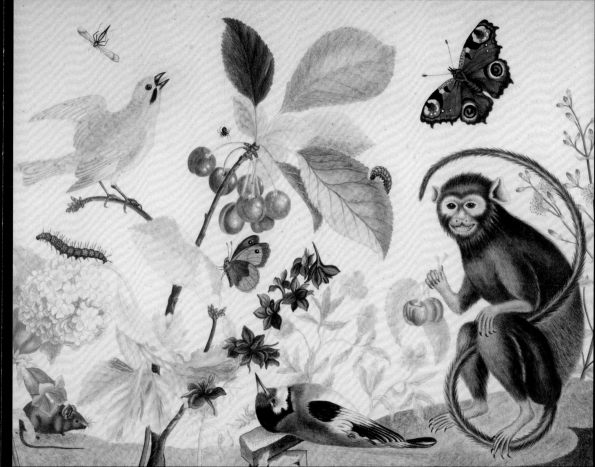

Enlightened taste

The Scottish painter Allan Ramsay (1713–84) was one of the greatest portraitists of the Enlightenment and was admired across Europe. He was the official painter to George III (1738–1820) for over 20 years, during which time he painted this portrait of the Scottish peer William Colyear, Viscount Milsington, later 3rd Earl of Portmore (1745–1823). Ramsay moved in intellectual circles and as well as being one of the most highly regarded portraitists of his day, he published poetry, letters and essays on subjects ranging from taste to political theory.

Ramsay's sophisticated portraits were noted for their sensitive and naturalistic approach to capturing his sitters' personalities. Milsington holds a tricorn hat and informally leans on a table covered in books, showing him to be a fashionable and scholarly aristocratic man of his times. Ramsay was so popular that successful compositions were sometimes repeated. Another portrait by him in the National Trust's collections, of George William Coventry, 6th Earl of Coventry (1722–1809), shows the sitter in exactly the same clothes, pose and setting (Croome Court, Worcestershire, NT 170909). DT

Penrhyn Castle, Gwynedd · William Colyear, Viscount Milsington, later 3rd Earl of Portmore · *Allan Ramsay* · *c.1764–5* · *Oil on canvas* · *124.5 x 99cm* · *NT 1420352* · *‡ 2005*

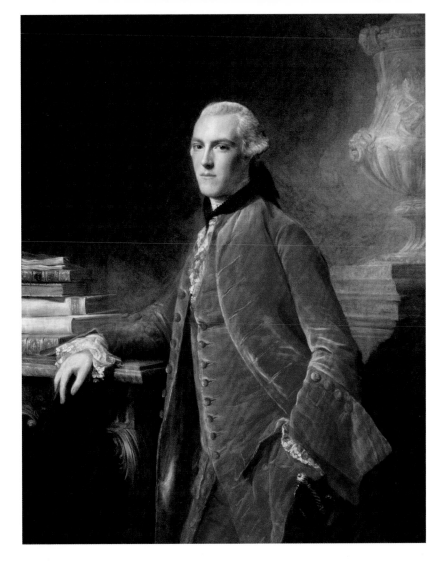

The art of love

Sir Rowland Winn (1739–85), 5th Baronet, and his Swiss wife, Sabine d'Hervart (1734–98), married in defiance of his family's opposition in 1761. This portrait by Hugh Douglas Hamilton (1740–1808) records a moment of optimism in their marriage when Sir Rowland had inherited Nostell, the family's Yorkshire estate, and was hoping to make a name for himself in the world of politics and high society. Here, the image of fidelity and refinement, they appear in the library at Nostell, which had recently been completed by the architect Robert Adam (1728–92).

Lady Winn drapes her hand intimately over her husband's shoulder while he gazes back at her, presumably to make a favourable comparison between her beauty and that of the bust of Venus, the ancient goddess of love. The painting originally hung in the Winns' house in St James's Square to show off their taste and marital success to their London visitors. Hamilton was careful to accurately depict the furniture by Thomas Chippendale (1718–79) and paintings by Antonio Zucchi (1726–95), which remain in the library to this day. JC

Nostell, West Yorkshire · Sir Rowland Winn, 5th Bt and Sabine Louise d'Hervart in the Library at Nostell · *Hugh Douglas Hamilton · c.1767-8 · Oil on canvas · 100.3 x 125.7cm · NT 960061 · ‡ 1986*

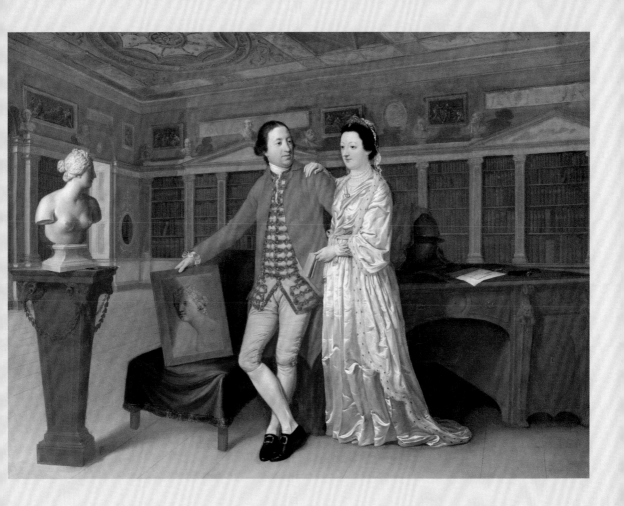

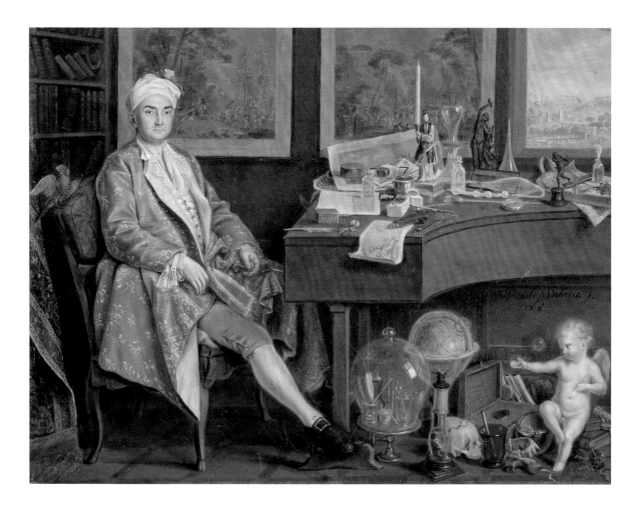

A casual approach to learning

An Italian collector sits at a harpsichord, under which are various *vanitas* objects, such as a putto blowing bubbles, a crown and a skull, which remind us of the brevity of life. Similarly, there are two engravings on the wall behind him, after paintings by Antoine Watteau (1684–1721), one of which can be understood as a warning against living for sensual pleasures. However, the man in his study clearly enjoys intellectual pursuits. As well as the books behind him, the harpsichord and floor are covered with objects that show his artistic and scientific interests. Even his fashionable 'banyan' gown and turban, an expensive way of presenting a casual appearance at home, are a sign of his good taste and intellectual leanings.

The artist was the German painter Wenceslaus Wehrlin (1740–80), who worked in Italy at the courts of Turin and Florence (where he was known as Venceslao Verlin). He is not a well-known artist now and this picture is unusual in a British collection despite the allure of its subject for Grand Tourists. DT

Wimpole Hall, Cambridgeshire · An Italian Collector in His Study · *Venceslao Verlin (Wenceslaus Wehrlin)* · *1768* · *Oil on panel* · *35 x 42cm* · *Signed and dated on harpsichord: Wincesl. Wehrlin F./1768* · *NT 207799*

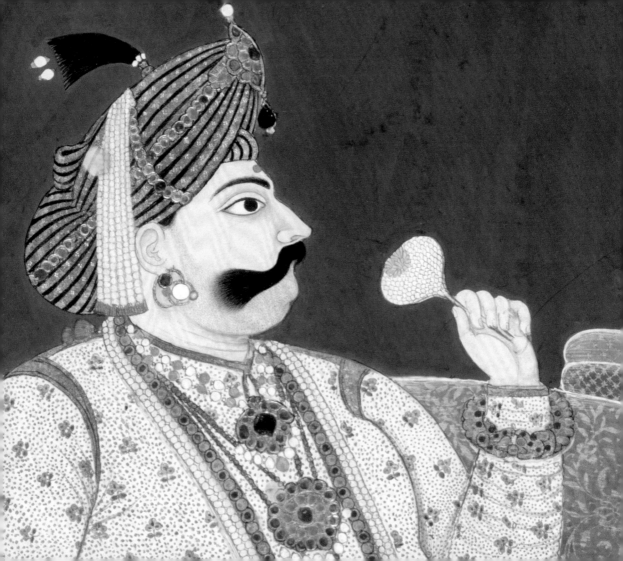

Majesty in miniature

The ruler of Thanjavur in southern India sits in splendour while a servant wafts a fly-whisk in the air. The unknown miniaturist, trained in the 18th-century Thanjavur style, has worked with tiny brushes and rich pigments to capture a wealth of details. Real gold embellishes the picture, along with fragments of beetle wing, used to replicate the lustre of emeralds in the jewellery.

A label in English on the back of the picture describes it as a portrait of Maharaja Pratap Singh (r.1739–65), although the sitter has more recently been identified as his son and successor to the throne, Tulsaji (r.1765–86). It was given to Lady Henrietta Clive (1758–1830), wife of the East India Company's governor of Madras (Chennai), by Tulsaji's adopted son, Sarabhoji II (r.1798–1832). By such a gift, Sarabhoji must have hoped to strengthen his relationship with the new presiding power in the region. JC

Powis Castle, Powys · Maharaja Pratap Singh or Tulsaji of Thanjavur · *Thanjavur 'Company' school* · *c.1770* · *Gouache, gold and beetle wing on paper* · *43 x 35.5cm* · *NT 1180663* · *Acquired with support from the National Heritage Memorial Fund, 1999*

A visitor from China

Huang Ya Dong (*c.*1753–?) was only about 23 when this portrait was painted but he had already lived an exceptional life. Some two years before, he used his connections in the East India Company to make the long voyage from Guangzhou (Canton) in China to London, 'partly from curiosity, and a desire of improving himself in science, and partly with a view of procuring some advantages in trade'. Well-informed for his age, he was sought after in learned circles for his knowledge of Chinese medicine, botany and ceramic manufacture.

The artist was Britain's most successful portraitist, Sir Joshua Reynolds (1723–92), who sensitively captured the likeness of this rare visitor from China. The pose, costume and setting of the portrait are designed to be emphatically Chinese, although they would have appeared incongruous back in Guangzhou, where red conical hats were the preserve of senior state officials and it was not the done thing to sit cross-legged on furniture. Huang subsequently returned to China to begin a career in business, leaving behind this compelling image as testament to his stay in Britain. JC

Knole, Kent (The Sackville Collection) · Huang Ya Dong · *Sir Joshua Reynolds, PRA* · *c.1776* · *Oil on canvas* · *130 x 107cm* · *NT 129924*

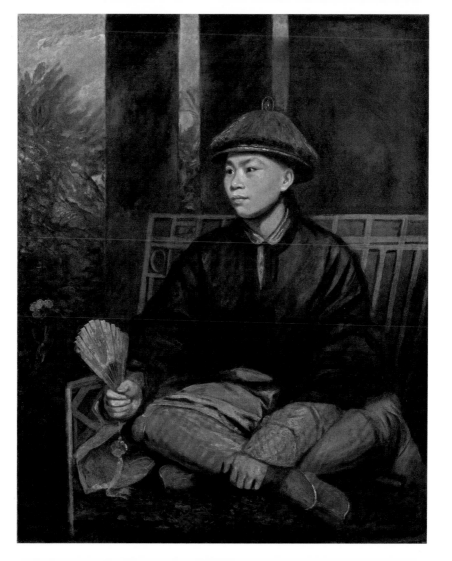

A different world

The painter William Hodges (1744–97) accompanied Captain James Cook (1728–79) as the official artist on his second voyage to the Pacific. The awe-inspiring natural beauty of the Polynesian island of Tahiti was conveyed by Hodges in the drawings and painted sketches he made there and in the larger canvases he painted on his return. This picture of Tautira (Oaitepeha) Bay was exhibited at the Royal Academy in 1776 with its pair, *A View of Matavai Bay on the Island of Otaheite (Tahiti)* (Yale Center for British Art, New Haven), where they fascinated visitors.

This is an important visual document of Tahiti around the time of the island's first contact with Europeans, depicted by an artist trained in the Western painting tradition. Although Hodges produced a realistic landscape, based on close study, he exaggerated some of the geographical features for dramatic effect. He also exoticised the Ma'ohi culture, showing a carved, wooden *ti'i* (a deified ancestral figure), and prominent naked, tattooed women, which add a Western idea of sensuality and otherness to his presentation of Tahiti as an idyllic and bountiful paradise. DT

Anglesey Abbey, Cambridgeshire · View of Oaitepeha Bay, Tahiti · *William Hodges, RA · 1776 · Oil on canvas · 90 x 135.6cm · Signed and dated: Hodges – 76 · NT 515553*

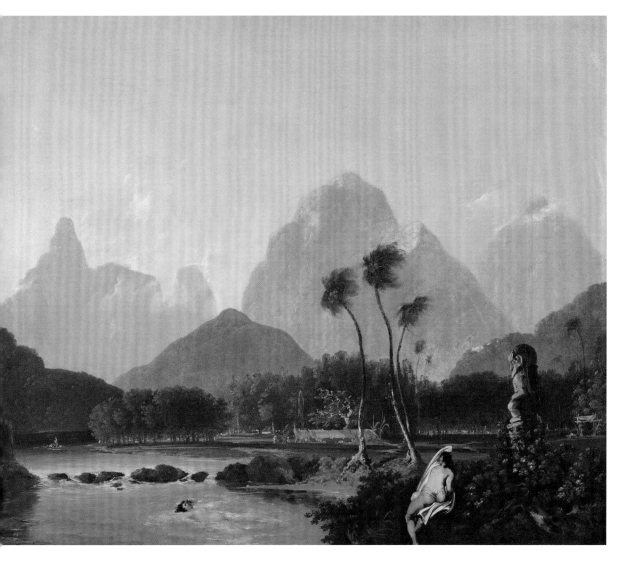

Making history

This imposing composition by Benjamin West (1738–1820) depicts a turning point in British colonial history. General James Wolfe (1727–59) is seen falling in combat beneath the Union Flag, just as his army declares victory over the French at the Battle of Quebec in 1759. In the 18th century, Britons traced their emergence as the dominant imperial power in North America back to this very moment. West fuses the traditions of portraiture and grand history painting with great originality, surrounding Wolfe's stricken form with his staff. Among them, an indigenous man wearing a pouch of the Northeastern Peoples sits pensively on the ground, perhaps contemplating the consequences of European power politics for his people and their colonised land.

Wolfe and this highly popular composition were capable of inspiring strong patriotic emotions. This is the fourth version of the picture that West painted and was probably commissioned by Frederick Augustus Hervey, 4th Earl of Bristol and Bishop of Derry (1730–1803), who remarkably referred to Wolfe as 'my military saint, who deserves much more to be canonized than any religious one I ever read of'. JC

Ickworth, Suffolk · The Death of General James Wolfe · *Benjamin West,* PRA · *1779* · *Oil on canvas* · *152.5 x 216cm* · *NT 851783* · ‡ *1956*

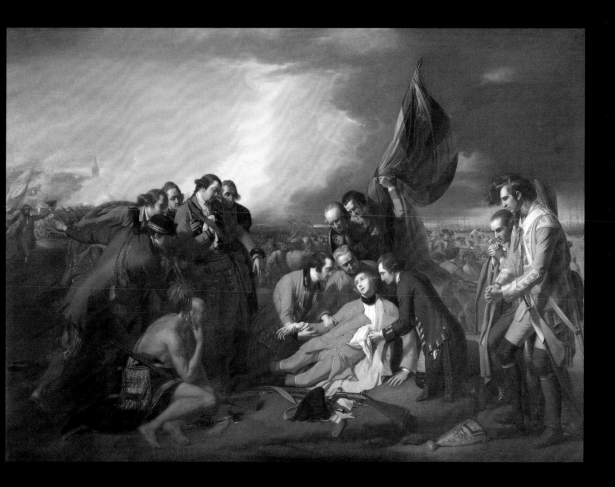

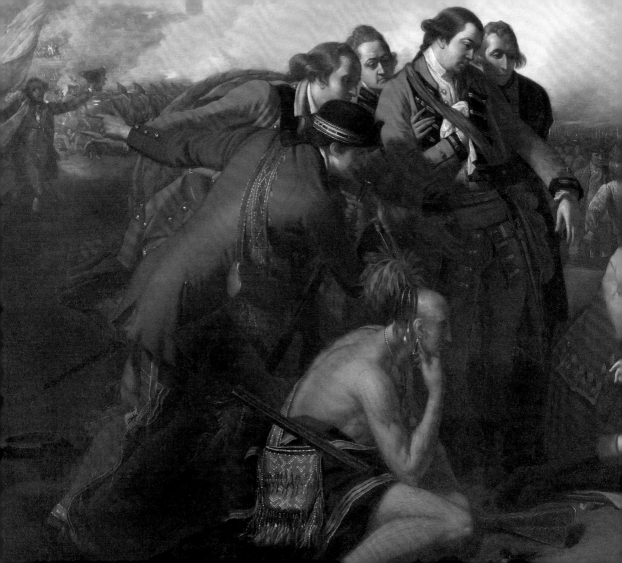

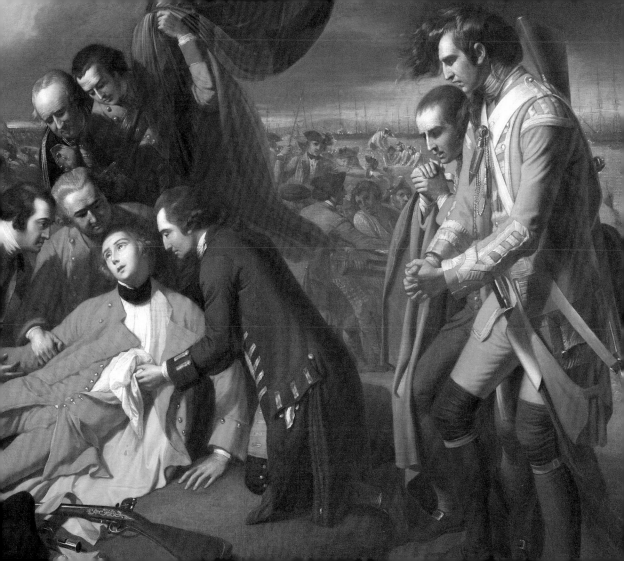

Making a suitable match

Lady Henrietta Herbert (1758–1830) is shown in her late teens, pulling on a glove as she prepares to walk in the countryside behind her. Typical of contemporary, gendered aristocratic portraiture, she is portrayed to promote her marriageability. Painted by the greatest portraitist in London, Sir Joshua Reynolds (1723–92), she is shown in the latest fashion and with tall, powdered hair. However, a mezzotint copying the original portrait when it was finished shows that her hair has been altered and her scarf and elaborate hat have been added later.

In 1784 Henrietta married Edward Clive, 2nd Lord Clive (1754–1839), who was created Earl of Powis following the death of her brother, the previous earl. It was through this marriage that her family estates passed to the Clive family. Henrietta was a renowned mineral collector and cataloguer, a botanist and writer. Her journals recording her travels in southern India, where her husband was the governor of Madras (Chennai), are important as examples of early female travel writing and as descriptions of 18th-century colonial experience. DT

Powis Castle, Powys · Lady Henrietta Herbert, later Countess of Powis · *Sir Joshua Reynolds, PRA* · *1777* · *Oil on canvas* · *140.3 x 112.3cm · NT 1181064 · ‡ 1992*

Fancy dress

The fashions worn by Archibald Hamilton (1770–1827) in this portrait were 150 years out of date when it was painted in 1786. The teenager's long flowing hair, lace collar and blue silk doublet all hark back to the court of Charles I and its glory days prior to the English Civil War. That period was idealised as a lost age of gallantry in the 18th century and people liked to wear cavalier costumes like this to masquerades.

There were also artistic reasons for this choice of dress. It reminded patrons of the paintings of Sir Anthony van Dyck (1599–1641), who was generally believed to be the greatest portraitist who had ever lived. Colourful silks also created an opportunity for virtuoso brushwork. Here, Thomas Gainsborough (1727–88) went to town on Hamilton's doublet, creating shimmering, three-dimensional effects with just a few shades of blue paint. Gainsborough idolised Van Dyck and his last words are said to have been, 'We are all going to Heaven and Van Dyck is of the party.' JC

Waddesdon Manor, Buckinghamshire · Lord Archibald Hamilton · *Thomas Gainsborough, RA · 1786 · Oil on canvas · 76.2 x 63.2cm · Waddesdon 2558 · Bequeathed by James de Rothschild, 1957*

Female fortitude

Night is drawing in over the Hudson River and a woman in red is being held at gunpoint. This is the scene that unfolded in October 1777 during the American War of Independence when Lady Harriet Acland (1750–1815) crossed enemy lines to come to the aid of her injured husband, Major John Dyke Acland (1747–78). Here we see her, balanced precariously in a small boat, accompanied by two servants and the British army chaplain, who carries a large white flag declaring their peaceful mission. The party was kept on the river until morning when, 'half dead with anxiety and terror', they were admitted into the American camp.

Having nursed her husband back to health, Lady Harriet returned to Britain. While accompanying her husband on the campaign, she had taken careful note of the indigenous peoples and landscapes she encountered, recording her observations in a diary that was published. Her act of 'female fortitude' went on to enjoy public acclaim. This painting by Robert Pollard (1755/6–1839) was reproduced as a print in 1784 along with a sensational account of the adventure. JC

Killerton, Devon · Lady Harriet Acland Crossing the River Hudson · *Robert Pollard* · *c.1784* · *Oil on canvas* · *49.5 x 64.1cm* · *NT 922301*

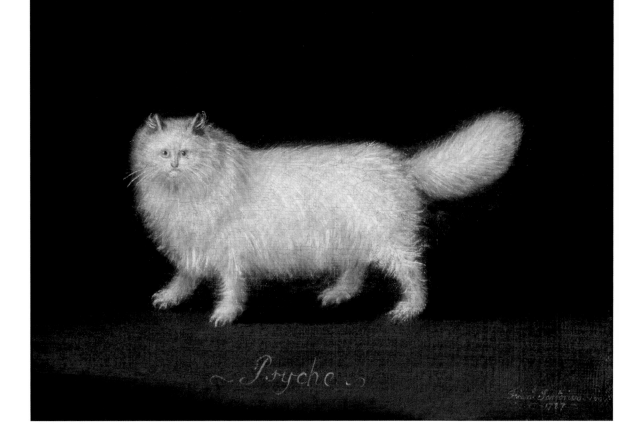

Pryche

A cat with soul

A pair of yellow eyes stare accusingly out of a preposterous ball of fluff. They belong to Psyche, an 18th-century domestic cat. Her luxuriant fur shows that she is of the exclusive Persian breed, so named because they are traditionally believed to have been imported from western Asia. The shadowy interior in which she stands to attention – as if alarmed by some unseen disturbance – brings out her snowy whiteness.

The painting does not have a long history at Fenton House, so we will probably never know who Psyche belonged to. They certainly cherished their expensive pet, however, naming her after the classical goddess of the soul. Indeed, the task of immortalising this beloved animal was entrusted to Francis Sartorius I (1734–1804), an artist better known for painting the thoroughbred horses of the aristocracy. JC

Fenton House, London · 'Psyche', a White Persian Cat · *Francis Sartorius I · 1787 · Oil on canvas · 21.9 x 29.5cm · Inscribed: Psyche; signed and dated: Frans. Sartorius Pinxt 1787 · NT 1449066*

The artist at work

The celebrated French portraitist Elisabeth Louise Vigée Le Brun (1755-1842) was famous for acquiring the patronage of Queen Marie Antoinette (1755-93). This self-portrait was painted in Naples in 1791, after she had fled revolutionary France. This is a second version of a self-portrait she painted the year before, now in the Uffizi Gallery in Florence. In this picture she shows herself in the act of painting her daughter Julie (1780-1819). It was commissioned by Frederick Hervey, 4th Earl of Bristol and Bishop of Derry (1730-1803), whose portrait by Vigée Le Brun, painted the year before in Naples with the volcano Vesuvius in the background, is also at Ickworth.

Vigée Le Brun depicts herself in fashionable clothes that are unlikely to be the sort she would have worn while painting, which emphasises her position as a famous and successful artist. Radically, she shows herself with an open mouth and visible teeth. Contemporary viewers would have seen this as scandalously bad manners, with one commentator declaring it 'an affectation which artists, connoisseurs and people of good taste are unanimous in condemning'. DT

Ickworth, Suffolk · Self-portrait · *Elisabeth Louise Vigée Le Brun · 1791 · Oil on canvas · 99 x 81cm · Signed and dated bottom left: L.E. Vigée Le Brun/Naples 1791 · NT 851782 · ‡ 1956 (transferred to the National Trust, 1990)*

Love lost and found

Angelica Kauffman (1741–1807) was doubly exceptional in the 18th-century British art world. Not only was she a woman in a profession dominated by men, she succeeded where most failed in making a living from the prestigious genre of history painting. Swiss-born, she spent 15 of her best years in London, specialising in scenes of ancient history and mythology that were believed to demand higher intellectual and technical ability than other visual arts.

In this large picture, Kauffman depicts the classical boy-god of love, Cupid, leading the wine god, Bacchus, to the bed of Ariadne. This Cretan princess has just been abandoned by the hero Theseus on the Greek island of Naxos and, weeping, throws her hand up in distress.

The god is instantly besotted. This was one of the most popular subjects in history painting and the challenge was for artists to express the story anew each time. Kauffman's interpretation displays the emotional refinement for which her works were admired. It was commissioned in 1792 by the 2nd Lord Berwick (1770–1832) for his Shropshire house, Attingham Park, where it still hangs. JC

Attingham Park, Shropshire · Bacchus and Ariadne · *Angelica Kauffman, RA · 1794 · Oil on canvas · 246.4 x 165.1cm · Signed and dated: Angelica Kauffmann Pinx Romae 1793 · NT 608953*

Winning form

This image of the celebrated 18th-century racehorse Hambletonian (1792–1818) is one of the greatest pictures ever painted by the famous horse painter George Stubbs (1724–1806). Hambletonian is held by a man in a top hat, possibly the trainer Thomas Fields (1751–1810), while a stable boy rubs him down with a cloth, post-race. The horse takes up the majority of the canvas, which adds a monumentality to his depiction, and his active pose makes him look like a horse on a classical frieze. Stubbs shows Hambletonian wound up with nervous energy after his exertions, with his muscles showing, his tail up, his ears back and mouth open as he catches his breath. The setting is Newmarket Heath in Suffolk, with a rubbing-down house and viewing stands in the background.

Hambletonian is depicted after winning a famous match race against a horse called Diamond, watched by a huge crowd, that took place on 25 March 1799.

This late picture by Stubbs was commissioned by Hambletonian's victorious owner, Sir Henry Vane-Tempest, 2nd Baronet (1771–1813). An icon of British horse painting, it shows us Stubbs's empathy for the exhausted racehorse rather than any overt display of celebration or ownership. DT

Mount Stewart, County Down · Hambletonian, Rubbing Down · *George Stubbs, RA* · *1800* · *Oil on canvas* · *209.6 x 367.3cm* · *Signed and dated bottom centre: Geo: Stubbs 1800* · *NT 1220985*

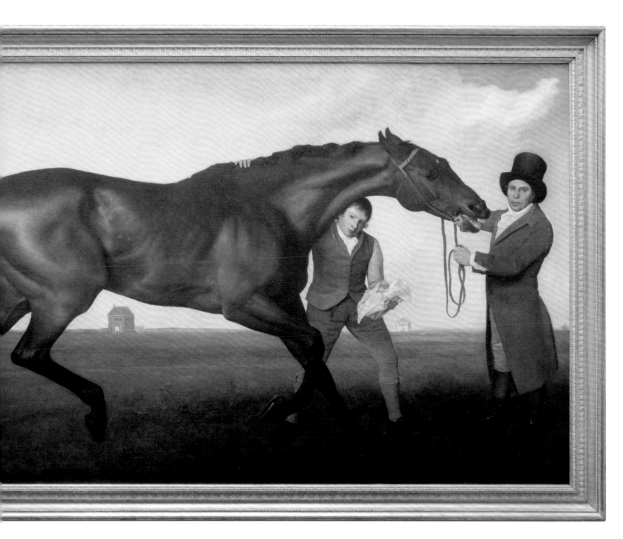

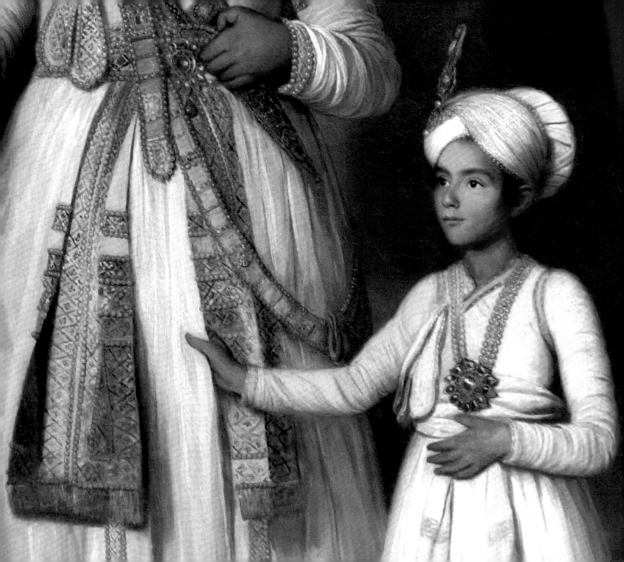

Princely portraits

Azim-ud-Daula, Nawab of the Carnatic (1775–1819), and his son Azam Jah (c.1800–25), were painted by the Irish artist Thomas Hickey (1741–1824) in 1803. The nawab's weapons and jewels emphasise his wealth and status, although his political power had been removed from him by the time the picture was painted. In 1801 he signed the Carnatic Treaty, which gave him British support as titular ruler, but handed his governing authority to the British East India Company.

Hickey was one of a number of skilful painters on the subcontinent who portrayed top-ranking members of the British East India Company and their Indian allies. This double portrait, in the grand European style, with classical columns and swagged curtains behind the sitters, was painted for the nawab. He gave it as a gift to Edward Clive, 1st Earl of Powis (1754–1839, see page 130), when Clive relinquished the governorship of Madras (Chennai) in 1803. DT

Powis Castle, Powys · Prince Azim-ud-Daula, Nawab of the Carnatic, and His Son, Azam Jah · *Thomas Hickey · 1803 · Oil on canvas · 236.2 x 144.8cm · Signed and dated on reverse: Thomas Hickey pinxit 1803 · NT 1180953 · ‡ 1963*

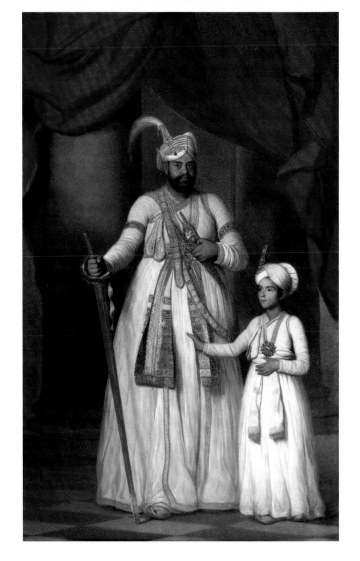

Inspiration strikes

On the morning of 16 July 1808, Dunham Massey in Cheshire weathered a dreadful lightning storm. An old oak tree on the estate was obliterated by what must have been an extraordinarily powerful thunderbolt. Splinters were found as far as 372 yards from where the trunk had been. The devastation was captured by John Boultbee (1753–1812), who had started out as a landscape artist but had since specialised in skilful but rather unimaginative animal paintings. In fact, he had probably been summoned to the estate by the 5th Earl of Stamford (1737–1819) to paint one of his favourite horses.

The Dunham lightning strike seems to have jolted Boultbee into a late moment of inspiration. The pale insides of the tree are dramatically picked out against the shadowy wood, seemingly touched by the first raking light to break through the storm clouds. So poetically does he evoke the violence of the thunderbolt and the totality of the destruction that the image assumes the status of a brooding meditation. JC

Dunham Massey, Cheshire · An Oak Tree Struck by Lightning in Dunham Park · *John Boultbee · 1808 · Oil on canvas · 75 x 90cm · Signed and dated: J. Boultbee 1808 · NT 932272*

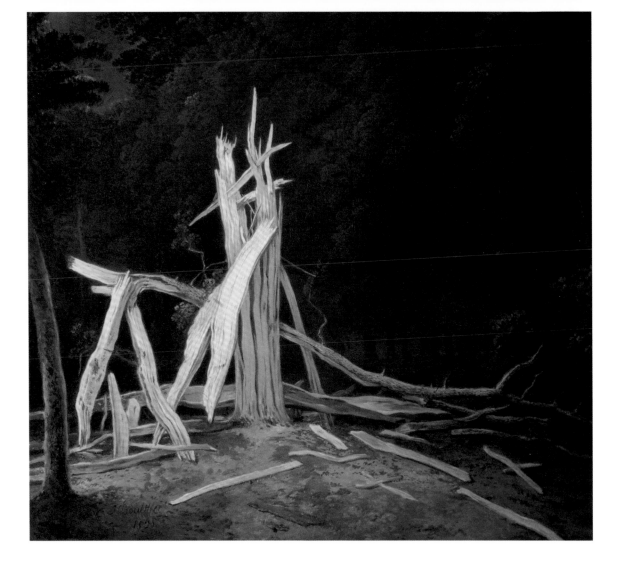

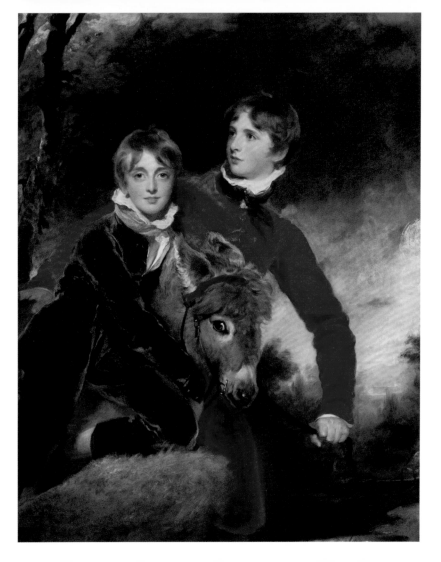

Gentle dispositions

Sir Thomas Lawrence (1769–1830) was a master of painting children and their lively interactions. Here he depicts William Pattisson (1801–32) and his younger brother, Jacob (1803–74), out for a walk in a wild Romantic landscape. While Jacob gazes back at us, William looks up, apparently concerned by the dark clouds gathering overhead. Keen to press on, he strains the lead of the donkey. Are we to imagine that the animal, the whites of its eyes flashing, has frozen in fear at the onset of the storm?

Commissioned in 1811, the Pattisson boys were barely children at all by the time the portrait was finished in 1817 – the year William turned 16. Their mother had grown understandably impatient. The resulting picture was much admired when it was finally exhibited, however, and was felt to 'bespeak gentle dispositions and minds of a high order'. JC

Polesden Lacey, Surrey · The Masters Pattisson · *Sir Thomas Lawrence, PRA · 1811–17 · Oil on canvas · 127 x 101.6cm · NT 1246452*

Effort and ease

Few artists have laboured as doggedly towards a vision as did John Constable (1776–1837) on his depiction of the opening of Waterloo Bridge. Between witnessing the event in 1817 and completing a painting he was happy to exhibit in 1832, he worked up multiple versions. The endeavour became something of a nightmare, which he compared to 'a blister [that] begins to stick closer & closer & disturb my nights'.

This composition is the most impressive of these preparatory works. At 8 feet wide, it is even larger than the exhibited piece. It is not clear whether it is an abandoned attempt at a finished painting or one of the full-scale oil sketches that were an innovative part of his practice. Certainly, the painting shares the extraordinary freedom of those special works, its spontaneous paint surface belying the effort behind its creation. JC

Anglesey Abbey, Cambridgeshire · Embarkation of George IV from Whitehall: the Opening of Waterloo Bridge, 1817 · *John Constable, RA* · *c.1820–5* · *Oil on canvas* · *148 x 243.2cm* · *NT 515574*

A genius comes to stay

The sun sets on the pleasure grounds at Petworth House, its long rays glancing off the Upper Pond and casting long shadows across the lawn. The scene is populated by cricketers and spectral groupings of fallow deer, two of which lock horns. The clouds, almost carved out of thick paint, glow above the cool, hazy shadows of the distant wooded hill. Summer fades into autumn.

This is Petworth as seen through the eyes of one of its most famous visitors, J.M.W. Turner (1775–1851), who regularly stayed there as the guest of his patron, the 3rd Earl of Egremont (1751–1837). It is one of a set of four pictures that he was commissioned to paint for insertion into the panelling of the Carved Room. It remains there to this day, facing out onto the very view it depicts. JC

Petworth House, West Sussex · The Lake, Petworth, Sunset, Fighting Bucks · *Joseph Mallord William Turner, RA · c.1830 · Oil on canvas · 62 x 144.3cm · NT 486627 · ‡ 1956 (allocated to Tate, 1984; on loan from Tate to the National Trust)*

A commemoration of service

A tradition of commemorating loyal staff at Erddig in Wales began in the 1790s with six portraits commissioned from the Denbigh artist John Walters (1721–97) by Philip Yorke I (1743–1804). His son, Simon Yorke II (1771–1834), continued his father's idea by commissioning William Jones (active 1818–c.55), an artist from Chester, to paint these three estate workers. Like his father's commission, Yorke had affectionate doggerel verse he wrote about the sitters added to the compositions.

Here we see dignified, full-length portraits of the woodman Edward Barnes (1761/2–?), 'Long may He keep the Woods in Order …', proudly holding his Denbighshire Militia sword; Thomas Pritchard (1762/3–?), 'Our Gardener old and run to seed / Was once a tall and slender reed …', who rests in a chair; and the carpenter Thomas Rogers (1781–1875), 'Another Chip from Nature's Block …', in his workshop. DT

Erddig, Wrexham · Edward Barnes, Woodman; Thomas Pritchard, Gardener; Thomas Rogers, Carpenter · *William Jones · All 1830 · Oil on canvas · All 114.3 x 91.4cm · All inscribed with verses by Simon Yorke II, all inscribed with name, occupation and age of sitter and dated 1830 · NT 1151281, NT 1151288 and NT 1151280*

Naked ambition

For centuries, the naked human body was central to the most ambitious forms of European art. Academies taught young artists how to draw the nude so that they could incorporate expressive poses into grand narrative paintings on lofty moral themes. The career of William Etty (1787–1849) played out the paradox at the centre of this tradition – that the intellectual ends of high art were to be reached by such deeply physical, and often sensual, means.

Etty was perhaps simply too good at capturing the naked body's 'lustre, beauty and fleshiness', as he called it, and was never quite able or willing to bring it to heroic abstraction. In this academic study, we witness his ability to evoke sheer flesh-and-blood presence. Bold strokes of crimson in the background imbue the whole composition with the impression of bodily warmth. JC

Anglesey Abbey, Cambridgeshire · Academic Study of a Male Nude · *William Etty, RA* · *c.1830–5* · *Oil on paper on canvas* · *47.6 x 27cm* · *NT 515703*

The rock face

In a landscape of jagged rock, men hewing slate with pickaxes look minuscule against the monumental crags of the quarry. In the right-hand corner the artist, Henry Hawkins (c.1796–1881), sketches the scene before him.

In 1832, the 13-year-old Princess Victoria visited Penrhyn Slate Quarry near Bangor, Gwynedd, and it is believed that this painting was commissioned either to anticipate or commemorate the visit of the future queen. The quarry was owned by George Hay Dawkins Pennant (1764–1840), who was at this time using the wealth derived from the slate industry and enslaved labour on Jamaican sugar plantations to rebuild Penrhyn Castle. The slate quarries at Penrhyn and nearby Dinorwic were the largest in Wales, and probably the world, in the 1830s.

Hawkins's depiction of the quarry is unabashed in its celebration of 19th-century Welsh industry. The artist draws on the Romantic sublime in art and literature, where humans are eclipsed by the awe-inspiring wonders of nature. At Penrhyn, the unforgiving landscape is part natural, part man-made, and signals the human attempts to harness nature that were at the core of early industrialisation in Britain. SH

Penrhyn Castle, Gwynedd · The Penrhyn Slate Quarry · *Henry Hawkins · 1832 · Oil on canvas · 137 x 189cm · NT 1421761 · ‡ 1961 (transferred to the National Trust, 1983)*

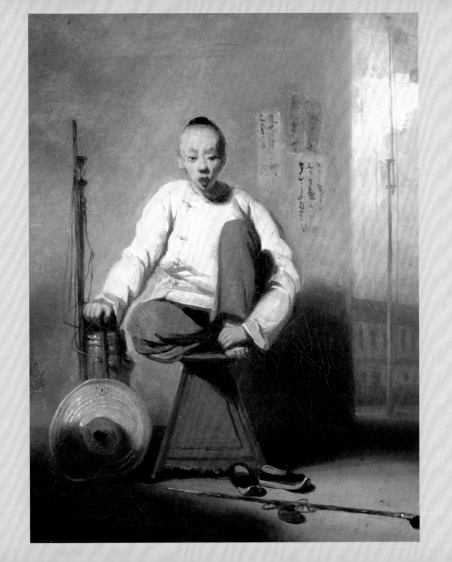

Cutting corners

A travelling barber sits on a street corner in early 19th-century Guangzhou (Canton), waiting for passing trade. He perches on a triangular box containing razors, tweezers and so on, and rests his hand on a red charcoal stove for heating water. Also at his side is his pole, which he would carry on his shoulders, stove and box dangling at each end. In the background, the Stars and Stripes flag tells us that this barber has set up his pitch close to the American 'factory', where the Chinese imperial authorities permitted traders from the United States to carry out their business.

This scene was captured by the London-born painter George Chinnery (1774–1852), who had previously worked in British India. By this time, he had settled in Macau and made regular visits to Guangzhou, where he took commissions from wealthy Chinese and Western patrons for portraits and scenes of everyday life. This piece bridges the two areas of his work, depicting an ordinary man in the street with some of the singularity and specificity of portraiture. JC

Coleton Fishacre, Devon · A Barber outside the American Factory in Canton (Guangzhou, China) · *George Chinnery* · *1836* · *Oil on canvas* · *20 x 16cm* · *Signed and dated: GC 1836* · *NT 85205* · *Bequeathed by Dorothy Dillingham, 2004*

A regal hound

A curly-coated spaniel sits facing right with a quill pen in its mouth, an opened letter with a red seal between its paws. Tilco was a toy Sussex spaniel given to Queen Victoria by the Earl of Albemarle. This oil-on-board sketch was a study for Landseer's *Macaw, Love Birds, Terrier and Spaniel Puppies* (now at Balmoral Castle). In the finished work Tilco is posed with Islay, Queen Victoria's Skye terrier, a macaw and two lovebirds.

The English painter and sculptor Sir Edwin Landseer (1802–73) was a favourite artist of Queen Victoria and Prince Albert. Landseer is most celebrated for his lifelike painted depictions of animals, particularly horses and dogs, and was encouraged by his painting teacher, Benjamin Robert Haydon (1786–1846), to dissect animals in order to get a sense of their muscular and skeletal structure. SH

Anglesey Abbey, Cambridgeshire · Queen Victoria's Spaniel 'Tilco' · *Sir Edwin Henry Landseer, RA · 1838 · Oil on board · 34.9 x 27.6cm · NT 515453*

The language of flowers

A young woman sits sewing. She has green ribbons, a dog rose and harebells at her neck. Her cap is trimmed with dark pink foxgloves.

The story of the Scottish painter Euphemia 'Effie' Gray (1828–97) and the English Pre-Raphaelite Brotherhood painter Sir John Everett Millais (1829–96) falling in love while touring Scotland in 1853 with the critic and artist John Ruskin (1819–1900), is well known. Ruskin was Gray's husband and Millais' friend and mentor. Gray and Ruskin had married in 1848 but the marriage remained unconsummated. Gray gained an annulment and she and Millais married in 1855.

In *Flora Symbolica* (1869) John Henry Ingram cites harebells as traditionally symbolic of both the frailty of love and of Effie's homeland, Scotland. The associations of beautiful but poisonous foxgloves are complex, but for Millais the flower's association with the Virgin Mary may represent Effie's purity. This intimate portrait undoubtedly captures the artists' burgeoning love. SH

Wightwick Manor, West Midlands · Euphemia 'Effie' Chalmers Gray, Mrs John Ruskin (1828–97), later Lady Millais, with Foxgloves in Her Hair (The Foxglove) · *Sir John Everett Millais, RA* · 1853 · *Oil on millboard* · 37.3 x 35.1 x 5cm · *Monogrammed 'JM' and dated 1853* · *NT 1288934*

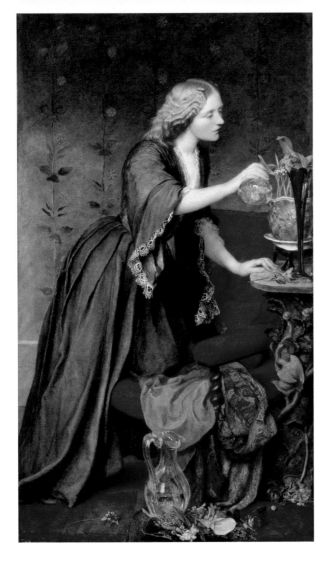

A study in mauve

In an interior of rich mid-Victorian colour, a young woman with 'rippling golden hair' and dressed in a purple 'medieval' gown has cast aside a tumble of exotic flowers to kneel on a chair and water a lily of the valley.

Jane 'Jeanie' Hughes Nassau Senior (1828–77) had an extraordinary career as Britain's first woman civil servant, and was a highly active philanthropist. She was also a good friend of the artist George Frederic Watts (1817–1904) and of Octavia Hill (1838–1912), a founder of the National Trust.

This portrait of Jeanie, with its jewel-bright tones, nods to Pre-Raphaelitism. However, this is the modern interior of Little Holland House in Holland Park, with its arsenic-green wallpaper. The purple of her dress was achieved with the new aniline dyes discovered by William Henry Perkin in 1856. This balance of modernity and medievalism, allied with the artist's affection for his sitter, makes this painting one of Watts's most enduringly popular works. SH

Wightwick Manor, West Midlands · Jane 'Jeanie' Elizabeth Hughes Nassau Senior · *George Frederic Watts, RA* · *1858* · *Oil on canvas* · *202 x 133cm* · *NT 1288949*

A celebration of Tyneside industries

In a scene packed with vibrant colour and detail, Edinburgh-born artist William Bell Scott (1811–90) celebrates the industries of mid-19th-century Tyneside. A locomotive wheel is forged by burly men wielding hammers, a train crosses Stephenson's high-level bridge, coal barges ply their trade along the River Tyne, and fishermen gather by the dock. An Armstrong gun and shells are shown in the foreground, and a child sits on the gun barrel with food for her working father. Smoke belches, flames rise and sunbeams cut through the scene.

Iron and Coal is the last of eight works painted by Bell Scott between 1856 and 1861 that mark significant historical moments in the English border region once known as the Kingdom of Northumbria. The paintings were commissioned in 1855 from Bell Scott by Sir Walter Trevelyan (1797–1879) for the Courtyard at Wallington, and his cousin and heir Charles is depicted as the burly workman wielding a hammer furthest left. Bell Scott mixed in Pre-Raphaelite circles and was good friends with Dante Gabriel Rossetti (1828–82). However, unlike Rossetti, who famously could not paint 19th-century life, this painting is unashamedly modern, depicting the industries that made Tyneside a centre of British manufacturing. SH

Wallington Hall, Northumberland · In the Nineteenth Century the Northumbrians Show the World What Can Be Done with Iron and Coal · *William Bell Scott* · *1861* · *Oil on canvas* · *185.4 x 185.4cm* · *NT 584372*

Best in show

The Cumbrian artist William Taylor Longmire (1841–1914) knew his sheep. The son of a farmer-cum-butcher, he was destined to follow in his father's footsteps but was encouraged to take up painting as a profession by the local vicar. Here he shows a pair of Swaledale sheep facing each other on a rare sunny day in the Lakeland fells. Bred to withstand harsh mountainous conditions, they are best known for their meat. With obvious appreciation, the painter captures their strong straight backs and rounded front shanks, promising fine cuts for the table.

Longmire is reputed to have worked simultaneously on up to 20 pictures, going from one to another applying a single colour at a time. What his paintings lack in finesse, they make up for in charm. One of his admirers was a prize-winning sheep breeder called George Browne of Townend (1834–1914). His farmhouse contains this piece and six comparable livestock paintings by Longmire – each perhaps commissioned to commemorate a victory at competition. JC

Townend, Cumbria · A Swaledale Sheep and Ram in Profile · *William Taylor Longmire* · *c.1860–80* · *Oil on board* · *35.5 x 54cm* · *NT 478841*

In the garden

An elegant and fashionably dressed young woman stands at a table in a verdant garden. She gazes intently at the pistol she holds, and a number of different firearms are placed on or propped against the table. Behind her sit a woman covering her ears and a bewhiskered man with his arm around the woman.

The Crack Shot depicts a woman engaged in an activity that would normally be regarded as the preserve of men at that time. It is a striking subject even for French artist James Tissot (1836–1902), who gained fame as a painter of fashionable women participating in modern life. The identity of the woman is unknown, but the man could be Tissot's friend and early patron Thomas Gibson Bowles (1842–1922), the founder of *Vanity Fair* and *The Lady*, and the maternal grandfather of the Mitford sisters. SH

Wimpole Hall, Cambridgeshire · The Crack Shot · *Jacques Joseph Tissot (name anglicised by the artist to 'James') · 1869 · Oil on canvas · 67.3 x 46.4cm · NT 207841*

A modern Venus

Adelaide Chetwynd-Talbot (1844–1917), as depicted here by Sir Frederic Leighton (1830–96), cuts a striking figure. The posy of pink roses (symbol of the Roman goddess of love) and the nod to white classical drapery of her dress deliberately frame Adelaide as a modern Venus.

Leighton's depiction of Adelaide as part contemporary 'Aesthetic' muse, part classical goddess of love, is one of the great paintings of British Aestheticism, which celebrated beauty rather than morality in art. It encapsulates Leighton's work as the most celebrated Neo-classical painter of the Victorian age, whose work was nonetheless closely allied to Aestheticism during the 1870s and 1880s. The painting was commissioned from Leighton by Adelaide's husband, the politician Adelbert Brownlow Cust, 3rd Earl of Brownlow (1844–1921). The Brownlows were part of 'The Souls', a loosely knit group of aristocratic and intellectual Aesthetes and patrons of the arts. SH

Belton House, Lincolnshire · Lady Adelaide Chetwynd-Talbot, Countess Brownlow · *Sir Frederic Leighton, Lord Leighton, PRA · 1879–80 · Oil on canvas · 244 x 166cm · NT 436073 · Acquired with assistance from the National Heritage Memorial Fund, 1984*

Real people

These small paintings reflect big changes in art and society. They were made by Henry Herbert La Thangue (1859–1929), who was born in London but devoted his art to the depiction of working country people. This boy and young woman were painted not long after La Thangue had finished his training in France, where he had been inspired by Realism and its concern with the painful impact of 19th-century industrialisation on rural life. For all their immediacy, the pair share an elegiac quality, as if capturing the population of a disappearing world.

As well as Realism, Impressionism had also made an impact on La Thangue in France, which can be seen here in the freshness of his colours and mark-making. The boy was probably painted rapidly in the open air. La Thangue's avant-garde style and subjects did not always appeal to the London art establishment, which he found exclusive and undemocratic. Instead, he found his greatest admirers among the growing number of collectors in the industrial North of England. JC

Standen House, West Sussex · Study of a Boy in a Black Hat / Study of a Young Cornishwoman · *Henry Herbert La Thangue, RA · c.1885–7 · Oil on panel · 33 x 22.9cm and 36.8 x 24.8cm · NT 1214784 and NT 1214785*

One moment in time

In 1889 on the North Lawn of the medieval manor house Ightham Mote, the tenants, Mary Lincoln 'Queen' Palmer (1850–94) and her daughter Elsie (1873–1955), played bowls with their guests, including Violet Sargent (1870–1955), the youngest sister of the American artist John Singer Sargent (1856–1925).

Another of those house guests was Singer Sargent himself, and he captured this moment in time in this painting. Distinctly different from the society portraits for which the artist is today celebrated, *A Game of Bowls* is composed as a large-scale English landscape but painted in an Impressionist style. It betrays Sargent's artistic origins in the French avant-garde circle of painters that included his mentor Claude Monet (1840–1926). The painting was shown at the New Gallery in 1890, a London venue famous for championing Pre-Raphaelite and Aesthetic painting. The painting was bought by Queen Palmer, who was a great supporter of and advocate for Aestheticism in arts and culture and who hosted guests such as Henry James, Ellen Terry and William Morris at Ightham Mote. When Queen died in 1894, the painting was inherited by Elsie, whose portrait Sargent had also painted in 1889–90. SH

Ightham Mote, Kent • A Game of Bowls • *John Singer Sargent, RA* • *1889* • *Oil on canvas* • *142.9 x 229.2cm* • *NT 826023* • *Acquired with assistance from the National Heritage Memorial Fund and the Art Fund as well as private donations, 2018*

Enduring love

In a haunting landscape of ruins entwined by briar roses, two lovers dressed in drapery of brilliant deep blue embrace sadly.

This 1894 version in oils is a copy of an 1873 watercolour (private collection) that was damaged when it was mistaken for an oil painting and coated with egg white to enhance the glaze while it was being photographed in France. The watercolour was later successfully restored and is regarded as the masterpiece of the artist's 'blue period'.

The Pre-Raphaelite artist Sir Edward Burne-Jones (1833–98) was inspired to paint *Love Among the Ruins* by the 1855 poem of the same name by Robert Browning (1812–89). Browning expresses the idea that love is eternal while material glory and power are ephemeral. Like his mentor Dante

Gabriel Rossetti (1828–82), Burne-Jones saw romantic love as an eternal and spiritual force, the quest for which he made the central theme of his work. This enduring love is symbolised by roses in many of his works, and the twining wild roses in *Love Among the Ruins* echo the mass of thorny blooms in his small *Briar Rose* (Sleeping Beauty) series of paintings (Museo de Arte de Ponce, Puerto Rico, 1871–3). SH

Wightwick Manor, West Midlands · Love Among the Ruins · *Sir Edward Coley Burne-Jones, ARA · 1894 · Oil on canvas · 96.5 x 160cm · Signed and dated, bottom right: EBJ 1894 · NT 1288953 · Originally acquired with the collection at Upton House, currently on display at Wightwick Manor*

Making an impression

Spencer Gore (1878–1914), best known for his theatrical scenes, nudes and landscapes, here depicts an unknown Frenchwoman sitting in front of a fireplace, with one arm on the back of her chair. The image, of unremarkable Edwardian domesticity, is enlivened by Gore's expressive, dabbing brushstrokes and his bold use of colour, such as the contrasting orange walls, blue mantel scarf and green picture frame.

Gore died of pneumonia when he was only 35, so was unable to fully develop his artistic style. This picture, painted four years before his early death, is therefore typical of his innovative late work, when he was influenced by the Post-Impressionist movement. Gore was a co-founder and the first president of the Camden Town Group of artists, and later a member of the artist-led London Group. The picture was bequeathed to the National Trust by the actor and art collector Peter Barkworth as part of a large group of modern pictures, including a second painting by Gore and a still life by Harold Gilman (1876–1919), one of Gore's Camden Town Group co-founders. DT

Fenton House, London · The Frenchwoman · *Spencer Gore · 1910 · Oil on canvas · 35.6 x 45.7cm · NT 1449103 · Bequeathed by Peter Barkworth, 2006*

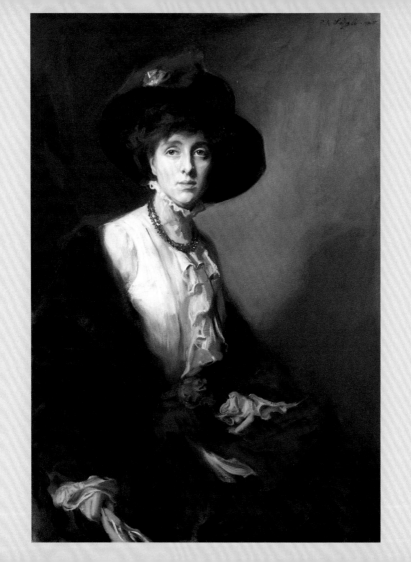

The portrait in the attic

A young woman, dressed in the fashion of 1910 with a high-necked ruffled cream blouse, amber necklace, fur stole, full dark skirt with a mauve rose at the waist, and large dark hat, sits gazing into the distance.

Vita Sackville West (1892–1962) posed for the Hungarian-born Edwardian society painter Philip de László (1869–1937) just before her 18th birthday. Her mother, Victoria Sackville West, Lady Sackville, insisted both on dressing Vita herself and that the artist, who admired his sitter's beauty, should waive his fee given his regard for her looks. Victoria's persuasiveness did not, however, extend to her daughter liking the resultant portrait, which Vita regarded as vacuous and Edwardian, and consigned to the attic throughout her life.

Philip de László was born in Budapest to a seamstress and a tailor of Jewish descent. Initially apprenticed to a photographer, de László won a place at the National Academy of Art. In 1892 he met Lucy Madeleine Guinness in Munich and they married in 1900. In 1907 they moved to London, where he was commissioned by royalty, and his work soon became the toast of Edwardian society. SH

Sissinghurst, Kent • Victoria (Vita) Mary Sackville-West, Lady Nicolson • *Philip Alexius de László de Lombos* • *1910* • *Oil on canvas* • *106.7 x 91.4cm* • *Signed and dated top right:* *P.A. László 1910-III* • *NT 803030* • ‡ *2007*

Both real and imagined

The illustrator and collector Charles Paget Wade (1883–1956) practised as an architect until 1911, when he inherited a large part of the family sugar and cotton plantation business in the Caribbean. The first of the plantations was bought by Wade's grandfather, Solomon Abraham Wade (1806–81), whose wife, Mary Jones (1817–1914), was a free-born Kittitian of African heritage. Some of Wade's inheritance was spent on acquiring Snowshill Manor in Gloucestershire, which he filled with an eclectic collection that included samurai armour, children's toys, musical instruments and kitchen utensils.

This painting shows a figure dressed in clerical robes standing at an open gate with steps leading to a building. According to an inscription in Wade's hand on the back of the painting, it was 'invented' (devised) during a visit to St Kitts in February 1910. Typical of many of his paintings and illustrations, the setting of this picture is probably a fantastical hybrid of real and imagined places. It was given by Wade, with Snowshill, to the National Trust in 1951. DT

Snowshill Manor, Gloucestershire · Robed Figure at the Gates of a Building · *Charles Paget Wade · 1910 · Oil on board · 36 x 25.5cm · Inscribed: Anno Dom 1910, inscribed on reverse: Inv. Feb. St. Kitts, 1910.* · NT 1336588

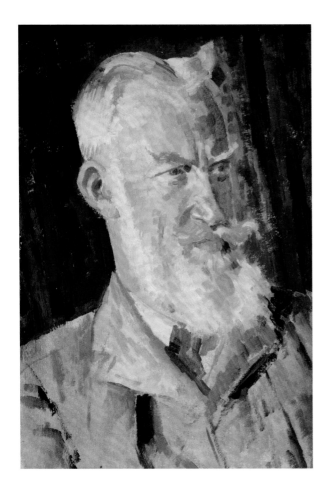

The aged original

The Irish playwright and critic George Bernard Shaw (1856–1950) was a popular and prolific writer. Also a political activist, he was an early member of the socialist Fabian Society, a founding director of *The New Statesman* magazine and a vocal champion of Joseph Stalin. Shaw was connected to the Irish Literary Revival and it was at a house party hosted by Augusta, Lady Gregory (1852–1932) at Coole Park in County Galway, a focal point for revival writers, that Shaw was painted by the Welsh artist Augustus John (1878–1961).

John produced six portraits of Shaw over eight days, describing this one as the best. Shaw, who was vain about his image, bought two of the portraits, despite having described this picture as 'an elderly caricature of myself' and 'the aged original' when later photographed beside it. It is, however, a fine example of the eccentric and brilliant John's portraiture. DT

Shaw's Corner, Hertfordshire · George Bernard Shaw · *Augustus John, RA · 1915 · Oil on canvas · 60.3 x 40cm · NT 1275285*

Sister arts

This portrait of the Modernist author Virginia Woolf (1882–1941) was painted by her sister, Vanessa Bell (1879–1961). At the time of its painting each sister was emerging as a bold, avant-garde practitioner in her chosen art form. Bell's passages of unblended colour and use of dark lines to describe outlines shows the inspiration of the Post-Impressionism of Cézanne, Van Gogh and Gauguin, whose works had only recently been seen in Britain. Woolf was finishing the draft of her first novel.

The author hated having her portrait taken. Duncan Grant (1885–1978) remembered her simply standing up and walking away in the middle of one sitting. It may be that Bell's rapid brushwork was hastened by this knowledge. The arms and hands have an unfinished look compared to the delicate rendition of the face. JC

Monk's House, East Sussex · Virginia Woolf · *Vanessa Bell* · *c.1912* · *Oil on panel* · *41 x 31cm* · *NT 768417*

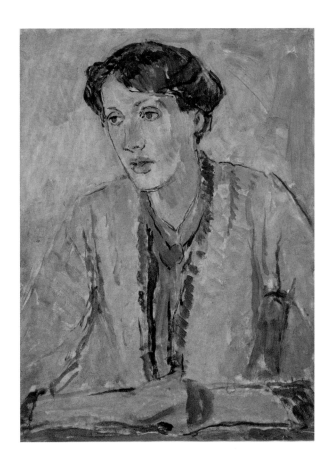

An idyll

On a blissful day on a Cornish beach, a soldier of the Royal Garrison Artillery is unwinding the puttees from his ankles. He has already discarded his cap and jacket and is getting ready to join another young man in the sparkling blue sea. Duty and discipline are being left behind and nature beckons. Henry Scott Tuke (1858–1929) specialised in such sunlit idylls populated by bathing youths. They often have a sensual quality, derived from the beauty of his models and his tremendous ability to capture the feeling of the outdoors. Small dabs of white paint speckle the surface of the picture to replicate the dazzling effect of the sun as it bounces off water and sand.

This picture hangs at Clouds Hill, the tiny cottage in Dorset that T.E. Lawrence (1888–1935) used as his retreat. It may not be a coincidence that the figure in the painting bears a striking resemblance to Lawrence. Tuke seems to have retouched the face in the summer of 1922, when the soldier-diplomat was on holiday in Cornwall, so it is possible that this is a portrait. JC

Clouds Hill, Dorset · A Soldier at Newporth Beach, near Falmouth · *Henry Scott Tuke, RA · c.1921–2 · Oil on canvas · 42.5 x 52.7cm · Signed and indistinctly dated: H. S. TUKE 19[?] · NT 628439*

Dressed for dinner

This picture must have looked both modern and timeless when James Penniston Barraclough (1891–1942) painted it in 1927. Here, in the corridor of a country house, stands a young woman in an evening dress. For centuries, aristocratic owners of large houses dressed formally each day for dinner. Modernity has arrived, however, in the form of her bobbed hair and knee-length skirt. Fewer families could afford to maintain these costly rituals after the First World War, but they remained an important part of upper-class life throughout the 1920s and 1930s.

The painting depicts Elinor Croft (1904–85), who went by the name Belinda, at Croft Castle in Herefordshire. Her family traced their history at the house back to the Middle Ages, although this impression of continuity is somewhat deceptive: they had sold the house in the early 18th century, only buying it back in 1923. JC

Croft Castle, Herefordshire · Belinda at Croft · *James Penniston Barraclough · 1927 · Oil on canvas · 100 x 71cm · Signed and dated: BARRACLOUGH 1927 · NT 537623*

AVE·SILVAE·DORNII·

Tricks of the eye

This is the sight that meets you when you enter the front door of Dorneywood House in Buckinghamshire. It is a large painting by Rex Whistler (1905–44) positioned to give the illusion of looking straight through the house to the rear garden. Everything in the painting is designed to give this effect, from the clever perspective to the fall of light around the columns, as if daylight is spilling into a darker interior. Whistler was a master of such playful *trompe l'oeil* pictures. The Latin inscription on the fictive architectural screen is a pun, meaning 'Hail the woods of Dorney'.

The real garden at Dorneywood looks rather different from this but it does have a croquet lawn, here populated by Edwardian figures.

Whistler has introduced a fanciful mix of classicism and mundanity, fiction and reality to the scene. The ancient gods Flora and Cupid are seen tentatively approaching the house, as if wary of the terrier snoozing on the terrace. This is Spot, the dog of the 1st Baron Courtauld-Thomson (1865–1954), who commissioned the work for the house, where he lived with his two sisters. JC

Dorneywood House, Buckinghamshire · Ave Silvae Dornii · *Rex Whistler* · *1928* · *Oil, wax, turpentine on canvas on panel* · *198.1 x 205.7cm* · *Inscribed: AVE SILVAE DORNII* · *NT 1507718*

Heaven emerging from hell

The decorative scheme Sir Stanley Spencer (1891-1959) painted for Sandham Memorial Chapel is his undoubted masterpiece. The chapel commemorates the life of Lieutenant Henry Willoughby Sandham (1876-1920). Sandham's sister, Mary Behrend (1884-1977), and her husband, John Louis Behrend (1881-1972), were Spencer's committed patrons. Spencer's scheme comprises 19 paintings that fill the walls of the chapel, and is among the most moving and poignant depictions of the First World War ever painted, despite showing neither bloodshed nor conflict. Spencer based the images on his own everyday experiences of the war at the Beaufort War Hospital outside Bristol and at the Macedonian front. He said the chapel paintings allowed him to recover his lost self from his memories of the war.

Spencer depicted many scenes of the banality of the soldiers' lives (see pages 196-7), such as the struggle to lay out kit for inspection, imbuing them with humour or with touching symbolism, such as the mackintoshes that hang like angels' wings from the soldiers filling water bottles. The use of symbolism was key to depicting the end of the war: weary soldiers leave their trenches to hear the news, under a mass of threatening barbed wire that floats above them like thunderclouds, while others prepare to step out of their cocoon-like mosquito nets to be reborn as the war's end is announced.

The culmination of the scheme is the enormous *The Resurrection of the Soldiers*, which fills the wall behind the altar. Dead soldiers emerge from the ground to realise their eternal peace among an astonishing sea of white crosses, people and recumbent war mules. The heavenly scene, although set in Salonika, also incorporates elements of the Hampshire countryside. DT

Sandham Memorial Chapel, Hampshire · Decorative scheme for Sandham Memorial Chapel · *Sir Stanley Spencer, RA · 1927-32 · Oil on canvas · Eight round-arched canvases approx. 213 x 185cm · Eight predella canvases approx. 105 x 185cm · Three other canvases of various dimensions attached to the wall · NT 790176-94*

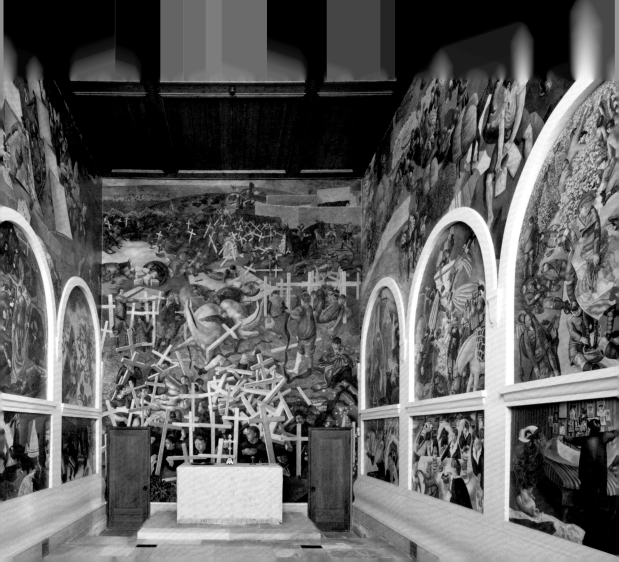

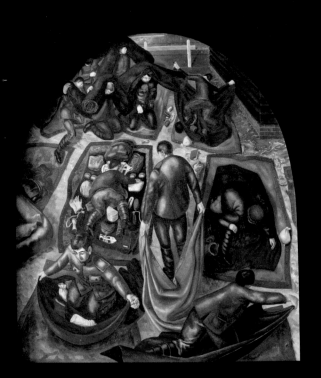 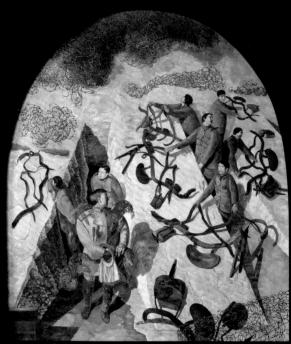

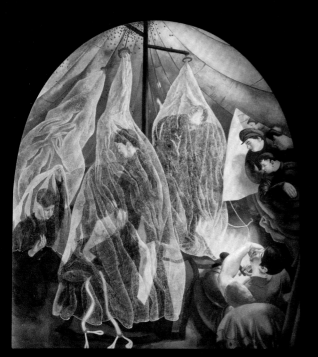

Interior worlds

This work of art by Max Ernst (1891–1976) is made up of two juxtaposed pictures. As a Surrealist, Ernst was interested in the brain's subconscious workings and named this piece *Le Passé et le présent (Past and Present)*. In each canvas, colourful forms float in and around two human heads, as if the contents of the mind have been made visible. One side is dominated by a wash of celestial blue, the other side fractured into irregular shapes. The title suggests that each half deals with contrasting experiences of memory and the present moment, although which is which is kept as a mystery.

The architect Ernö Goldfinger (1902–87) bought this piece from Ernst in 1934. It is now in the family home Goldfinger built for himself in Hampstead, north London. There are a further two pieces by Ernst among the house's significant collection of 20th-century works. JC

2 Willow Road, London · Le Passé et le présent (Past and Present) · *Max Ernst* · *1932–4* · *Oil on canvas* · *65.1 x 108.8cm* · *Signed: Max Ernst* · *NT 112786* · *Acquired with assistance from the V&A Purchase Grant Fund and a bequest from Geoffrey Dunne, 2000*

Staging beauty

This portrait of Princess Natasha (Natalia) Pavlovna Paley (1905–81) was painted by one of the 20th century's great stage, set and costume designers, Oliver Messel (1904–78). She is shown surrounded by a floating wreath of lilies and in front of an ethereal landscape, reminiscent of the artist's theatre sets.

Natalia Paley was a member of the imperial Romanov family of Russia. She was born in Paris, where her father, a son of Tsar Alexander II, was briefly banished. After the Revolution, she and the remainder of her family escaped, eventually returning to Paris, where she became a famous beauty and socialite, and finally settling in New York. She was a favourite model for celebrated photographers and was briefly an actress. Messel's stylised portrait captures Natalia's fashionable style as well as her self-confessed 'taste for sad things'. DT

Nymans, West Sussex · Princess Natalia Pavlovna Paley with Lilies · *Oliver Messel* · *c.1935* · *Oil on canvas* · *74.5 x 61.5cm* · *NT 1206470*

Community theatre

This scene of quiet industry takes place in the theatre at Smallhythe Place in Kent. It is 1939 and the woman sitting on the stage is Edith 'Edy' Craig (1869–1947). She had set up the theatre in the 17th-century barn in memory of her mother, the actress Ellen Terry (1847–1928). The stage is evidently being made ready for a production, and as Edy rummages in her work basket, a curtain is being hung and a script marked up.

The picture was painted by Clare 'Tony' Atwood (1866–1962), who had been Edy's partner since 1916, along with the author Christopher Marie St John (1871–1960). At the centre of the Smallhythe community, these three talented women lived together in a loving relationship until Edy's death in 1947. Performances still take place in the barn theatre – a remarkable legacy of their efforts. JC

Smallhythe Place, Kent · The Barn Theatre, Smallhythe Place · *Clare 'Tony' Atwood* · *1939* · *Oil on canvas* · *91.6 x 71cm* · *Signed and dated: CLARE ATWOOD. 1939* · *NT 1118237*

The country house in wartime

Lacock Abbey appears illuminated against the darkness of an abstract, stormy sky. The artist, John Piper (1903–92), visited Lacock in March 1942. He was an official war artist during the Second World War and was in south-west England to survey the German bomb damage to nearby Bath. Piper's wartime pictures, which include moving images of Coventry Cathedral sketched the day after it was destroyed in the Coventry Blitz of 14 November 1940, are considered his finest works.

This painting, centred on Lacock's Gothick Hall, shows his enduring fascination with historic English architecture. Similarly, the shadowy trees that frame the composition are influenced by his experience as a theatre and opera set designer. Piper's vision of Lacock is typical of early British Neo-romantic painting, with its brooding palette and mysterious nostalgia, both of which were an artistic response to the ongoing horrors of the war. DT

Lacock Abbey, Wiltshire · Lacock Abbey, from the West · *John Piper* · *1942* · *Oil on canvas* · *75 x 138.5cm (framed)* · *Signed bottom right: John Piper* · *NT 996351* · *Bequeathed by Alec Clifton-Taylor through the Art Fund, 1986*

An abstract concept

Ben Nicholson (1894–1982) was one of the most highly respected English artists of the 20th century and a leading exponent of the abstract art movement. Abstraction as an art form looked away from the illusionistic traditions of Western art developed over the centuries, and instead referred to contemporary innovations in, for example, technology and philosophy. Nicholson was heavily influenced by the Neo-plasticism of the Dutch artist Piet Mondrian (1872–1944) and the Cubism of the Spanish artist Pablo Picasso (1881–1973), both of whom he knew.

Composition, Abstract Squares was painted while Nicholson was living in St Ives with his second wife, Dame Barbara Hepworth (1903–75, see opposite), where they were leading figures in the group of artists working there. With his recognisable style, it exemplifies Nicholson's contribution to the development of modern art, including its unornamented, linear geometric forms and circles, and spare colour scheme. DT

Mottisfont, Hampshire · Composition, Abstract Squares · *Ben Nicholson · c.1943–7 · Oil on canvas · 40.7 x 48.9cm · NT 769740 · Presented by Derek Hill through the Art Fund, 1996*

Ancient to modern

Although Dame Barbara Hepworth (1903–75) is best known as a key figure in international modernist sculpture, she also produced a large number of paintings and drawings. In this 1956 picture, *Figures (Delphi)*, we see two abstract human figures, painted in a subdued range of black, white and yellow.

In 1954, following a depression brought on by her divorce from her second husband, the artist Ben Nicholson (1894–1982, see opposite), and the death of her eldest son, she was taken on a recuperative holiday to Greece. Her time there appeared to have a cathartic effect and influenced much of her art afterwards. The figures here relate to Archaic Greek *kouroi* figurative sculptures, such as the brothers Kleobis and Biton carved by Polymedes of Argos. Sir George Labouchère (1905–99) bought the painting, and a sculpture by Hepworth, for his modern art collection at Dudmaston. DT

Dudmaston Hall, Shropshire · Figures (Delphi) ·
*Dame Barbara Hepworth · 1956 · Oil, pencil and gouache
on fibreboard · 76 x 38cm · NT 814221*

War and peace

Although it may not be obvious at first, this picture shows a laboratory on the former military site at Orford Ness, a shingle spit on the Suffolk coast. The highly strategic area was used for secret military testing through both world wars and the Cold War. The 'pagoda', in the left background, was built to test the effect of vibration and temperature stress on atomic bombs, while the structure in the centre housed a centrifuge that subjected parts of the bombs to G-forces. In 1993 the Ministry of Defence sold Orford Ness to the National Trust and a programme of developing the site as wildlife habitat and grazing land began. Along with nearby Havergate Island, managed by the Royal Society for the Protection of Birds, Orford Ness is now designated a National Nature Reserve.

The artist John Wonnacott (b.1940) is well known for his large portraits with complex compositions, but here he concentrates on capturing the mysterious simplicity of the spit landscape, laid out under a tranquil sky. A sense of the former danger of the site is mixed with the fragile beauty of the abandoned buildings and the moving symbolism of plants growing in cracks on the road that leads to the former military laboratory. DT

Westley Bottom, Suffolk · View of Military Remains at Orford Ness, Suffolk · *John Wonnacott* · *c.1994* · *Oil on canvas* · *92 x 122cm* · *NT 65142*

Glossary of terms

Aesthetic Movement · A movement in the arts and design, also known as 'Art for Art's Sake', the Aesthetic Movement flourished in Britain and America during the 1870s and 1880s. The movement, which was promoted by figures such as Oscar Wilde (1854–1900), encouraged a 'cult of beauty' that elevated art's capacity to evoke joy or pleasurable sensation over its traditional function as a vehicle for moral and other narratives. In painting, it is particularly associated with Dante Gabriel Rossetti (1828–82) and James McNeill Whistler (1834–1903), while in the applied arts it was translated into the commercial sphere by designer Christopher Dresser (1834–1904) and the famous London department store, Liberty & Co.

British Aestheticism *see* Aesthetic Movement

Cabinet picture · A small painting typically hung in a small room (or cabinet) dedicated to the private art collection of a connoisseur (such collections were especially popular in northern Europe in the 16th and 17th centuries). Since they were intended to be viewed at close range, their subject matter was often highly detailed and precisely rendered.

Conversation piece · Popular in the 18th century, conversation pieces depicted small groups of friends, family members or colleagues interacting in domestic or garden settings. These informal group portraits were popularised by William Hogarth (1697–1764), Arthur Devis (1712–87) and Johann Zoffany (1733–1810).

Diptych · A painting or relief carving composed of two panels, usually hinged so that it can be closed like a book to protect the decorated surfaces. Examples from Late Antiquity, often in ivory, were usually commemorative in function, while those from the Middle Ages depict religious scenes and were used for personal devotion (*see also:* Triptych).

Grisaille · A monochromatic picture executed in shades of grey, sometimes as a means of demonstrating technical virtuosity but also as a preliminary stage in oil painting or as a model for an engraver, etc.

Mannerism · Modern term for a style of art or architecture that exaggerates or intensifies its subject matter, rather than seeking to render it realistically or conventionally. Principally applied to Italian works of *c*.1520–1600, the term often describes an intellectually sophisticated style that consciously seeks to challenge established rules.

Ontbijt · Literally 'breakfast piece'; a type of still-life painting that began to appear in the Netherlands in the early 17th century,

characterised by highly realistic depictions of food, tableware and draped fabric.

Predella · One of a series of small narrative pictures inserted beneath a much larger painting above a church altar. *Predelle* were often used to illustrate scenes from the lives of the saints shown in the panels above them, and were sometimes used by the artist to try out styles and techniques deemed too risky for the larger panels.

Pre-Raphaelite Brotherhood · Formed in 1848, the 'PRB' initially comprised a small 'secret society' of artists including Dante Gabriel Rossetti (1828–82), Sir John Everett Millais (1829–96) and William Holman Hunt (1827–1910). Later, other artists, designers, writers and thinkers were associated with this loosely affiliated group, including William Morris (1834–96) and Sir Edward Burne-Jones (1833–98). The PRB sought to revitalise English art, ostensibly by emulating late medieval and early Renaissance art, and by opposing what they saw as the excessively mannered approach to painting favoured by the Royal Academy. Their works are often characterised by the use of brilliant colours, intense detail and elaborate symbolism, principally to treat biblical and literary subjects.

Putto · Taking its name from a Latin word for boy (*putus*), a putto is a chubby male child, often winged; the figure derived from Greek and Roman personifications of love.

Triptych · A picture or relief composed of three panels, typically constructed so that the wings are half the size of the central panel and can be folded over to protect it. They were often made as objects of private devotion, depicting the Madonna on the central panel and a saint on each of the wings (*see also*: Diptych).

Trompe l'oeil · Literally 'trick the eye', an illusionistic technique that uses perspective and foreshortening to create the impression that the painted scene is a real view. It was extensively used in late classical times and during the Italian Baroque.

Tronie · Associated with Dutch Golden Age and Flemish Baroque painting, a *tronie* (from a Dutch word of the period meaning 'face') depicts a single figure, usually in historical, exoticised or fanciful costume, or with an exaggerated facial expression. *Tronies* are usually studies of personal characteristics or traits (piety, martial courage, old age, etc.), or sometimes of particular emotions or sensations (pain, pleasure, anger, etc.).

Vanitas painting · An image designed to remind the viewer of the fleeting nature of life. Such paintings use a distinct visual vocabulary: skulls, hourglasses, flowers, decaying food, etc., to convey their moral message.

Compiled by David Boulting

Gazetteer of featured properties

For full details of every National Trust property, including further information about collections, opening times, events and facilities, please visit the National Trust website (www.nationaltrust.org.uk) and the National Trust Collections website (www.nationaltrustcollections.org.uk).

Anglesey Abbey, Cambridgeshire · 13th-century priory converted into a comfortable manor house with an outstanding collection of landscape paintings by Claude, Aelbert Cuyp, Richard Wilson, Gainsborough, Constable and Richard Parkes Bonington, and some 36 nudes by William Etty.

Ascott, Buckinghamshire · Jacobean farmhouse transformed by the Rothschilds in the late 1800s. The picture collection contains exceptional Dutch and Flemish cabinet pieces and a Madonna by Andrea del Sarto.

Attingham Park, Shropshire · Palladian house with French Neo-classical interiors and picture gallery by John Nash. The Grand Tour collections include works by Angelica Kauffman, Salvator Rosa and Luca Giordano. A fine self-portrait of Richard Cosway masquerading as Van Dyck is in the Octagon Room.

Basildon Park, Berkshire · Elegant Palladian house with a substantial collection of 17th- to 20th-century English and European paintings, including a dazzling series of Apostles by Pompeo Batoni and a garden still life by the 18th-century artist Anne Vallayer-Coster.

Belton House, Lincolnshire · Late 17th-century mansion with opulent Baroque interiors. The large picture collection contains portraits by Closterman, Kneller and Sir Frederic Leighton, one of the earliest pictures to reach England by the French Rococo artist François Boucher, and game pieces by Hondecoeter and Weenix.

Buckland Abbey, Devon · Once owned by Sir Francis Drake, this remodelled Cistercian abbey boasts spectacular Elizabethan plasterwork in the hall. It is home to a small collection of Dutch pictures, including a recently identified self-portrait by Rembrandt.

Cliveden, Buckinghamshire · Three-storey Italianate villa, once home to the Astor family, with important sculpture and tapestry collections. Paintings of note include John Singer Sargent's celebrated portrait of Nancy Astor and a royal conversation piece by Philippe Mercier.

Clouds Hill, Dorset · Tiny cottage and former retreat of T.E. Lawrence. Paintings by Gilbert

Spencer and Henry Scott Tuke hang in their original locations, with views of the Euphrates by Dora Altounyan, whom Lawrence met as an archaeologist in Syria.

Coleton Fishacre, Devon · Art Deco showpiece built in the Arts and Crafts style for the theatre impresario Richard D'Oyly Carte. Pictures include a portrait of a Canton barber by George Chinnery and a view of San Marco, Venice, by Sir Walter Sickert (loaned by the British Council).

Coughton Court, Warwickshire · Tudor and Gothic Revival house, home to the prominent Roman Catholic family of Throckmorton. It holds a good collection of 16th- to 19th-century paintings, with portraits by Lely, de Troy and Largillière, and a set of watercolour and gouache landscapes by Ducros.

Croft Castle, Herefordshire · Medieval castle refashioned in the 18th century. The picture collection is predominantly 17th- to 19th-century portraits, with notable works by Gainsborough and Lawrence.

Dorneywood, Buckinghamshire · 18th-century brick house and the official country residence for the Secretary of State and Ministers of the Crown. Paintings include a view of the Calanque de Cassis by Winston Churchill and an impressive *trompe l'oeil* by Rex Whistler.

Dudmaston, Shropshire · Traditional country house containing an outstanding collection of modern pictures and sculpture, including works by Ben Nicholson, Barbara Hepworth, Jean Dubuffet and Max Ernst, and a still life by the 18th-century Dutch artist Rachel Ruysch.

Dunham Massey, Cheshire · Georgian house built in 1720–38 for the 2nd Earl of Warrington. Its picture collection includes a rare allegory by Guercino, a series of 17th-century bird's-eye estate views, and Grinling Gibbons's earliest known work, *The Crucifixion*.

Dyrham Park, Gloucestershire · Baroque mansion built by William Blathwayt, Secretary at War to William of Orange, with a strong Dutch collection and paintings by Samuel van Hoogstraten, Andrea Casali and Bartolomé Esteban Murillo.

Erddig, Wrexham · Country house with Neo-classical interiors, fine examples of 18th-century Chinese wallpaper, a significant collection of portraits commemorating Erddig estate staff, other paintings by Gainsborough, Francis Cotes and Francis Wheatley, and amateur works by members of the Yorke family.

Felbrigg Hall, Norfolk · One of the finest 17th-century houses in Norfolk with a Grand Tour cabinet laid out as planned in the 1750s. The collection is primarily Dutch marines and Italian landscapes, with important works by the van de Veldes, Samuel Scott and Simon de Vlieger.

Fenton, London · Late 17th-century merchant's house in Hampstead with collections assembled by Lady Binning from 1936. The picture collection

includes a Constable cloud study, a panel by the Flemish Renaissance artist Adriaen Isenbrant, and works by the Camden Town Group.

Ham House, Surrey · Grand Stuart house on the banks of the Thames with an outstanding and well-documented collection of late 17th-century furniture and paintings by Elizabethan artists, including important miniatures still housed in their original closet.

Hardwick Hall, Derbyshire · One of the greatest of all Elizabethan houses, lavishly furnished with tapestries, wall hangings, plasterwork and paintings, including portraits by Daniel Mytens and a biblical landscape by Lambert Sustris.

Ickworth, Suffolk · Neo-classical house designed to accommodate a remarkable art collection. It includes exceptional pictures by Titian, Velázquez, Hogarth, Elisabeth Vigée Le Brun and Gainsborough, as well as an outstanding collection of miniatures.

Ightham Mote, Kent · One of the oldest medieval manor houses to survive in England. The collection includes a rare Grand Tour portrait of an Englishman by the Austrian Anton von Maron, and an evocative view of Ightham and its moat by Winston Churchill.

Kedleston Hall, Derbyshire · Neo-classical house with state rooms largely designed by Robert Adam to display the 1st Baron Scarsdale's painting and sculpture collection. Strong in Italian pictures, there are equally outstanding

works by Aelbert Cuyp, Salomon Koninck, Joos de Momper and Brueghel the Elder.

Killerton, Devon · Locus of a substantial estate inhabited by generations of the Aclands. Highlights include an intimate family portrait by Sir Thomas Lawrence, a rare oil by Francis Towne, and the original tableau of Harriet Acland crossing the Hudson by Pollard.

Kingston Lacy, Dorset · Grand 17th-century house, home to the Bankes family for more than 300 years. Masterpieces by Sir Peter Lely are preserved alongside important Spanish Golden Age pictures and internationally significant portraits by Rubens and Titian.

Knole, Kent · This Tudor archbishop's palace, home of the Sackville family for 400 years, has a spectacular art collection, singular in portraits, with key works by Kneller, Lely and Reynolds, and a portrait by Van Dyck of the female Renaissance painter Sofonisba Anguissola.

Lacock Abbey, Wiltshire · Unusual 16th-century country house with later Gothic-style alterations built on the foundations of a former nunnery. Its collection includes early photographic experiments by Henry Fox Talbot and a view of Lacock by the Modern British artist John Piper.

Monk's House, East Sussex · Intimate 16th-century cottage inhabited from 1919 to 1960 by Leonard and Virginia Woolf. It is hung with paintings by Vanessa Bell, Duncan Grant and other members of the Bloomsbury Group.

Montacute House, Somerset · Elizabethan prodigy house built of honey-coloured stone with an impressive collection of Tudor and early Stuart paintings loaned by the National Portrait Gallery, London. Later bequests include an ambitious oil by Daniel Gardner and fine portraits by Reynolds, Gainsborough, Hoppner and Lawrence.

Mottisfont, Hampshire · Priory converted into a house after the Dissolution of the Monasteries and transformed in the 1740s. The home of Gilbert and Maud Russell from the 1930s, it holds a major 20th-century art collection, a corpus of paintings by Derek Hill and extraordinary murals by Rex Whistler.

Mount Stewart, County Down · Neo-classical house and celebrated gardens, home to the Marquesses of Londonderry. Pictures include a superb collection of family portraits by Sir Thomas Lawrence, equestrian subjects, notably *Hambletonian* by George Stubbs, and important 20th-century portraits by de László, John Lavery and Edmond Brock.

Nostell, West Yorkshire · Palladian house built on the site of a medieval monastery. It is home to one of the best surviving collections of Chippendale furniture and some 200 oil paintings, including works by Pieter Brueghel the Younger, Angelica Kauffman and William Hogarth.

Nymans, West Sussex · Romantic, pseudo-medieval manor house built by Leonard Messel on his father's late-Victorian extension of an early 19th-century villa, with world-renowned gardens and rare plant collections. It holds paintings by the artist and stage designer Oliver Messel (1904–78) and a triptych panel of *c.*1600 attributed to Adam van Noort.

Penrhyn Castle, Gwynedd · Neo-Norman castle incorporating a medieval house and an 18th-century Gothic Revival mansion with important Dutch and Spanish 17th-century landscapes, genre paintings and portraits, and 16th-century Venetian *sacre conversazioni*. The collection also includes a wooded landscape by Gainsborough and a view of the Thames by Canaletto.

Petworth House, West Sussex · Inspired by the Baroque palaces of Europe, Petworth has by far the richest and best-documented picture and sculpture collection in the National Trust. With world-class holdings by Turner, Van Dyck and Sir Peter Lely, there are also masterpieces by Bosch, William Blake, Gainsborough, Reynolds, Teniers and Titian.

Polesden Lacey, Surrey · Regency villa with opulent Edwardian interiors and a magnificent collection of Dutch pictures. The collection includes important works by Pieter de Hooch, Ruysdael and Teniers, an early predella panel by Perugino, and fine portraits by Henry Raeburn and Sir Thomas Lawrence.

Powis Castle, Powys · Medieval castle remodelled by generations of the Herbert family. Alterations of *c.*1685 include a painted ceiling by

Antonio Verrio. The paintings are largely family portraits, with striking works by Reynolds, Romney, and Nathaniel Dance, also a Madonna and Child by Andrea del Brescianino. The miniatures include a cabinet portrait by Isaac Oliver and a Thanjavur group (Clive Museum).

Saltram House, Devon · Georgian mansion with rooms designed by Robert Adam. The Parker family was closely connected to Sir Joshua Reynolds, born nearby. Many works by him, Angelica Kauffman and Antonio Zucchi hang at Saltram, in addition to important works by Rubens and his studio.

Sandham Memorial Chapel, Hampshire · Commissioned as a memorial to Lieutenant Henry Willoughby Sandham, who died at the end of the First World War, the chapel contains a visionary series of paintings by Stanley Spencer to commemorate the 'forgotten dead'.

Shaw's Corner, Hertfordshire · Edwardian villa, home to playwright George Bernard Shaw and his wife Charlotte Payne-Townshend, with portraits by Augustus John and William Rothenstein, and landscapes of Ireland and Italy.

Sissinghurst, Kent · Elizabethan mansion and celebrated gardens restored by Vita Sackville-West and Harold Nicolson. Sissinghurst holds a large set of early 18th-century costume illustrations of Turkish men and women from the Court of the Ottoman Empire, and a striking portrait of Vita by Philip de László.

Smallhythe Place, Kent · 16th-century farmhouse inhabited by the actress Ellen Terry. It is an important place for LGBTQ heritage, with paintings by Clare 'Tony' Atwood, who lived with Terry's daughter Edy and her partner Christopher St John in the grounds.

Snowshill Manor, Gloucestershire · 16th- and 17th-century country house restored by the architect, collector and illustrator Charles Paget Wade. An eclectic collection includes paintings by Wade himself, a domestic interior by Richard van Bleeck, and a still life by Jacques Linard.

Standen, West Sussex · Arts and Crafts house built in 1891-4 by the architect Philip Webb. The interior contains simple woodwork and plaster decoration, William Morris wallpapers and textiles, and pictures by the Newlyn School, along with two excellent early portraits by William Nicholson of James and Margaret Beale.

Stourhead, Wiltshire · Palladian home of the Hoare family. The collection boasts history paintings by Nicolas Poussin, Cigoli and Anton Raphael Mengs, an exceptional series by Lagrenée the Elder and numerous British watercolours.

Tatton Park, Cheshire · Ancient estate and Neo-classical mansion with a magnificent art collection amassed principally by Wilbraham Egerton (1781-1856), including masterpieces by Van Dyck, Carracci, Guercino, Chardin and Canaletto.

Townend, Cumbria · 17th-century yeoman's farmhouse in the Lake District. It was home to the Browne family for over 400 years, with portraits by William Taylor Longmire of the family and their prize-winning sheep.

Uppark, West Sussex · Mansion of *c.*1690–4 with Rococo and Regency interiors, devastated by fire in 1989 (and later restored). Uppark has one of the finest surviving Grand Tour collections in Britain, including portraits by Pompeo Batoni, a *Four Times of the Day* series by Vernet, and six *Prodigal Son* tableaux by Luca Giordano.

Upton House, Warwickshire · Late 17th-century house remodelled in 1927–9 for Walter Samuel, the 2nd Viscount Bearsted. The large and important early picture collection includes a Bruegel once owned by Rubens, a miniature altarpiece by El Greco, and original paintings by Hogarth, Lievens, Metsu and van Ruisdael.

Waddesdon Manor, Buckinghamshire · French Renaissance-style chateau housing the influential collections of the Rothschild family. It has exceptional holdings in 17th-century Dutch landscape and genre painting, 18th-century French painting, and 18th-century British portraiture.

Wallington Hall, Northumberland · William and Mary house of *c.*1688, with Rococo stucco and an impressive Victorian mural by William Bell Scott depicting the history of Northumbria.

The collection also includes family portraits by Gainsborough, Hudson, Romney and Reynolds and two watercolours by J.M.W. Turner.

Westley Bottom, Suffolk · The National Trust's regional office for the East of England, with several paintings by 20th-century British artists inspired by the landscapes of Orford Ness, Suffolk.

Wightwick Manor, West Midlands · Victorian Aesthetic Movement house with an important collection of Pre-Raphaelite pictures and Arts and Crafts furnishings. Its collection features paintings and drawings by Rossetti, Dunn, Holman Hunt, Millais, Burne-Jones and Simeon Solomon, and works by women artists such as Elizabeth Siddal and Marie Spartali Stillman.

2 Willow Road, London · Modernist terraced house in Hampstead, designed by Ernö Goldfinger and completed in 1939. Largely acquired through Goldfinger's personal associations with artists, there are pictures by Eileen Agar, Prunella Clough, Max Ernst, Amédée Ozenfant and Bridget Riley.

Wimpole, Cambridgeshire · Mansion of superb architectural pedigree, with a chapel painted by James Thornhill and an important collection of narrative pictures and conversation pieces. Sir Joshua Reynolds's first entry to the first Royal Academy exhibition is here, as is James Tissot's *The Crack Shot*.

Compiled by Alice Rylance-Watson

Index

Acknowledgements

The authors are grateful to Tarnya Cooper and Sally-Anne Huxtable for contributing the introduction and several entries, for their help during the selection process, and for advising on the texts. We are also indebted to Emile de Bruijn, Emma Campagnaro, Juliet Carey, Jane Gallagher, Ian Grafton, John Guy, Harvey Wilkinson and Rebecca Wallis for their advice and assistance on various entries.

Sincere thanks are due to Christopher Tinker, the National Trust's publisher for curatorial content, who oversaw the editing, design and production of this book; and David Boulting, who copy-edited the texts, drafted the glossary, and undertook additional proofreading and picture research. We are also grateful to Matthew Young for his cover design; Patricia Burgess for proofreading the book; Susannah Stone for clearing image rights; Christine Shuttleworth for her index; and Richard Deal at Dexter Premedia.

Additional thanks to Alice Rylance-Watson, who contributed the gazetteer and conducted supplementary picture research; Laura Barker Wood, who carried out collections information research; Rebecca Hellen, Senior National Conservator, Paintings, for her advice during the proofing stages; and Katie Knowles for additional advice and assistance.

The National Trust gratefully acknowledges a generous bequest from the late Mr and Mrs Kenneth Levy that has supported the cost of preparing this book through the Trust's Cultural Heritage Publishing programme.

Picture credits

Every effort has been made to contact holders of the copyright in illustrations reproduced in this book, and any omissions will be corrected in future editions if the publisher is notified in writing. The publisher would like to thank the following for permission to reproduce works for which they hold the copyright:

Pages 2, 24, 25, 32, 34–5, 40, 41, 42–3, 44–5, 55, 56–7, 58, 74, 78–9, 86–7, 88, 90–1, 92, 93, 101, 109, 115, 124–5, 132, 148–9, 156, 158–9, 168, 172, 173, 182, 189 © National Trust Images/John Hammond • 4–5, 27, 36, 37, 82, 83, 118, 140–1, 154, 155, 162, 164, 165, 176–7 © National Trust • 6 © National Trust Images/Todd-White Art Photography • 8, 18–19, 28, 62, 71, 72–3, 95, 100, 102–3, 104, 105, 106, 110–11, 117, 120, 121, 127, 128–9, 130, 137, 145, 152 (both), 153, 160, 166, 168–9, 174 (both), 180, 184, 185, 191, 192 © National Trust Images • 9, 14, 30, 31, 48, 50, 51, 69, 134, 138, 146, 163, 178–9 © National Trust Images/Derrick E. Witty • 10 © National Trust Images/Andreas von Einsiedel • 12, 46, 47, 49, 67, 96, 97, 123 © National Trust Images/Matthew Hollow • 15 © National Trust Images/Lynda Hall • 16–17 © National Trust Images/John Bethell • 20, 21, 22, 38, 39, 60, 61, 80, 85 © National Trust Images/Angelo Hornak • 53, 170–1 © National Trust Images/Robert Thrift • 63 © National Trust Images/Chris Titmus • 64, 65 © National Trust Images/Prudence Cuming • 68 © National Trust Images/Rob Matheson • 77, 81 © National Trust Images/Christopher Hurst • 98, 131 © Waddesdon Image Library •

113 © National Trust/Andrew Fetherston • 142, 143 © National Trust Images/Clare Bates • 150–1 © Collection – Tate/Image: © Tate • 186 © The Estate of Augustus John/Bridgeman Images/Image: National Trust Images/John Hammond • 187 © The Estate of Vanessa Bell. All rights reserved, DACS 2021/Image: National Trust Images • 194–5, 196 (both), 197 (both) © The Estate of Stanley Spencer/Bridgeman Images/Image: National Trust Images/John Hammond • 199 © ADAGP, Paris and DACS, London 2021/Image: National Trust Images/Matthew Hollow • 201 © Estate of Oliver Messel. All Rights Reserved/Image: National Trust/Charles Thomas • 202, 203 © The Estate of Tony Atwood/Image: National Trust Images • 204–5 © The Piper Estate/DACS 2021/Image: National Trust Images • 206 © Angela Verren Taunt. All rights reserved, DACS 2021/Image: National Trust/Mr. Smith • 207 Barbara Hepworth © Bowness/Image: National Trust Images • 208 © Estate of John Wonnacott. All Rights Reserved/Image: National Trust Images

Page 6: *Sir Edward Herbert, later 1st Baron Herbert of Cherbury* by Isaac Oliver was purchased by private treaty with the help of grants from the National Heritage Memorial Fund, the Art Fund, a fund set up by the late Hon. Simon Sainsbury and a bequest from Winifred Hooper, 2016.

Published in Great Britain by the National Trust, Heelis, Kemble Drive, Swindon, Wiltshire SN2 2NA

National Trust Cultural Heritage Publishing

ISBN 978-0-70-780460-6

A CIP catalogue record for this book is available from the British Library.

10 9 8 7 6 5 4 3

Publisher: Christopher Tinker
Copy-editor: David Boulting · Proofreader: Patricia Burgess
Indexer: Christine Shuttleworth · Cover designer: Matthew Young
Page design concept: Peter Dawson, www.gradedesign.com
Additional picture research: Susannah Stone
Colour origination by Dexter Premedia Ltd, London

MIX
Paper from responsible sources
FSC® C114687

Printed in Wales by Gomer Press Ltd on FSC-certified paper

Unless otherwise indicated, dimensions are given in centimetres, height x width

Discover the wealth of our collections – great art and treasures to see and enjoy throughout England, Wales and Northern Ireland. Visit the National Trust website: www.nationaltrust.org.uk/art-and-collections and the National Trust Collections website: www.nationaltrustcollections.org.uk

‡ Indicates paintings accepted in lieu of inheritance tax by HM Government and allocated to the National Trust

THE AUTHORS

Dr John Chu is Senior National Curator, Midlands (Pictures and Sculpture) at the National Trust. He specialises in 18th-century British and French painting and has published and lectured widely on the art of Thomas Gainsborough and Joshua Reynolds. He previously worked at Tate on the Turner Bequest and has taught at the Courtauld Institute of Art and the University of Reading.

David Taylor is the former Curator of Pictures and Sculpture at the National Trust. He is an expert on early modern Scottish art, and previously worked at the National Galleries of Scotland and Historic Scotland. He has published widely in his field and has curated and co-curated exhibitions on images of 17th-century Scottish built landscapes, late-Enlightenment portraits, Peter Lely, Rembrandt, Stanley Spencer and the First World War, Dutch Golden Age pictures and British Baroque art.

ALSO AVAILABLE IN THIS SERIES

125 Treasures from the Collections of the National Trust

ISBN 978-0-70-780453-8